MW00364880

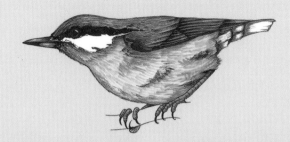

BIRDS WITH PERSONALITY

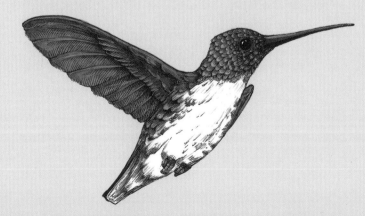

BIRDS

PERSONA

Georgia Angus

WITH

A Guide to 50 of
the World's Most
Beguiling Birds

LITY

Hardie Grant

EXPLORE

INTRODUCTION

INTRODUCTION

INTRODUCTION
INTRODUCTION
INTRODUCTION
INTRODUCTION

This book is about storytellers.

Every bird has a tale to tell, one that speaks about their life as an individual bird, about the evolution of their species and, especially, about the ecosystem they play a role in. Under different environmental pressures – be it extreme heat, harsh cold, predation, hunger, urbanisation, or competition for habitat – every species manifests a unique personality, shaped by the way they navigate these challenges. If a bird can't afford to hunt for itself, it must steal from other animals, like the audacious Inca tern, who steals food from the mouths of sea lions. If females of a species are choosy, males must learn to perform a seductive dance to woo them, as blue manakins do. In the pressure-pot of Earth's ecosystems, birds must quickly form a strategy for survival, or die out.

As a result, the tactics used by birds are often peculiar, extravagant, ingenious, wily, and memorable to boot – birds seem to be, certainly as much as us gregarious humans, rich in theatricality. One glimpse of an extravagant bird-of-paradise dancing, or a loud-mouthed rainbow lorikeet guzzling nectar, assures us of that. Each species tells a charismatic story, their narrative fodder made up of their ecological history. All it takes is a few moments of looking at a bird, allowing them to spark your curiosity, and their behaviour will speak volumes about the role they play in their environment.

You'll soon learn that the tales birds tell come in many genres. Some stories are about the hunt for resources. For example, the little spotted kiwis – the shy, flightless, and nearly sightless birds of New Zealand – use a sensitive bill and whiskers for foraging at night. These birds have adapted to an introverted life in the shadows. Clever keas raid trash cans for scraps, while bee-eaters hunt fleeing insects ahead of wildfires, capitalising on natural disaster. Each of these birds have adapted unique ways to exploit the resources they have at hand.

Of course, it's not always about food – some tales are of romance. These wooing strategies can sometimes border on the poetic and absurd: superb lyrebirds seduce partners by imitating the songs of other bird species. Hummingbirds position themselves in sunshine to best show off their iridescent feathers, while cotingas gather on arboreal dance floors to hoot for attention.

Other tales are of symbioses –
strange alliances between unexpected
creatures. The greater honeyguide in Africa
has learned to co-operate with humans, drawing
people to nearby beehives, and relishing in the traces
of honeycomb left after the raid. The 'i'iwi of Hawai'i have
co-evolved with native flowers, so that they pollinate blossoms as
they feed from them, ensuring the development of the next generation.
Red-billed oxpeckers may spend much of their lives on the back of a
single zebra or oxen, feeding on the ticks and ectoparasites that live
amongst the fur of their host.

Though birds are incredible creatures in their own right, the
most memorable stories they tell – beyond predation, reproduction,
exploitation and migration – are of a larger, more complex genre: the
relationship of interdependence between a bird and its habitat. A bird
is reliant on its environment, and vice-versa.

In the forests of South America, saffron toucanets guzzle palm fruit,
excreting seeds as they move through the canopy, ensuring the next
generation of plants thrive (amazingly, palm fruit seeds that have been
processed in the toucanet gut have a higher germination rate). Across
the northern hemisphere, Eurasian jays carry acorns and beechnuts
great distances, burying them in loamy soils as a future food cache,
inadvertently reforesting areas of open land as they go. Sunbirds and
honeycreepers pollinate plants as they feed, while superb lyrebirds
turn over tonnes of soil in the forest as they search for food, acting
as ecosystem engineers. The appearance – or absence – of water-
dwelling birds, such as roseate spoonbills and white-throated dippers,
speaks volumes about water quality in an area.

Seeing a single bird as a component of a complex ecological network is a recurring theme in this book. Although we may first appreciate birds for their beauty, the more we learn about a species, the more we can see how these animals embody whole ecosystems in their feathered, charismatic bodies.

The following pages offer fifty glimpses into the magnificent diversity of birds that can be seen across the planet. The entries will introduce you to delicate indicator species (animals that are very sensitive to minute environmental changes), stalwart ecosystem-engineers, tiny, restless pollinators, generous, fruit-munching parrots, balance-restoring predators, bashful vultures, and many other personalities. This selection serves as a glimpse into the immeasurable complexity of the ecosystems that make up our astonishing planet, and the marvellous ways birds survive within them.

Georgia

SNACK TIME

ENTRY GUIDE

Welcome, fledglings, to my introduction to the world of birds. While the sheer volume of species and information in field guides can initially seem overwhelming, starting with one or two memorable birds – perhaps one featured in this book – is a great way to begin familiarising yourself with different bird species. If you flick through the pages ahead, you'll see the layout is roughly ordered by bird type and preferred habitat. The book opens with smaller pollinating birds that live in lush forests. These lead in to entries on true rainforest-dwelling species, parrots, larger forest-floor dwelling birds, woodland birds, scrub and grassland birds, arid landscape species, predatory birds, and finally, closes out with waterbirds. The appendices (*see* p. 102) include several diagrams which allow you to compare species side-by-side.

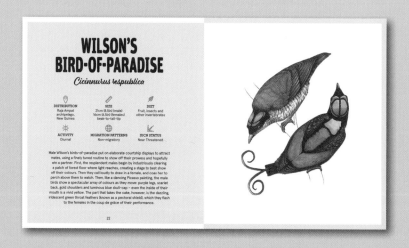

WILSON'S BIRD-OF-PARADISE

Cicinnurus respublica

DISTRIBUTION
Raja Ampat archipelago, New Guinea

SIZE
21cm (8.5in) (male)
16cm (6.5in) (females)
beak-to-tail-tip

DIET
Fruit, insects and other invertebrates

ACTIVITY
Diurnal

MIGRATION PATTERNS
Non-migratory

IUCN STATUS
Near Threatened

Male Wilson's birds-of-paradise put on elaborate courtship displays to attract mates, using a finely tuned routine to show off their prowess and hopefully win a partner. First, the resplendent males begin by industriously clearing a patch of forest floor where light reaches, creating a stage to best show off their colours. Then they call loudly to draw in a female, and coax her to perch above them to watch. Then, like a dancing Picasso painting, the male birds show a spectacular array of colours as they move: purple legs, scarlet back, gold shoulders and luminous blue skull-cap – even the inside of their mouth is a vivid yellow. The part that takes the cake, however, is the dazzling, iridescent green throat feathers (known as a pectoral shield), which they flash to the females in the coup de grâce of their performance.

22

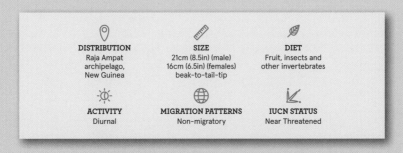

DISTRIBUTION
Raja Ampat
archipelago,
New Guinea

SIZE
21cm (8.5in) (male)
16cm (6.5in) (females)
beak-to-tail-tip

DIET
Fruit, insects and
other invertebrates

ACTIVITY
Diurnal

MIGRATION PATTERNS
Non-migratory

IUCN STATUS
Near Threatened

In each entry, you'll encounter several subheadings that describe different aspects of that particular species. These subheadings are as follows:

Distribution: The region where a given species lives. A world map showing all species' distribution is also included (*see* pp. xviii–xix).

Size: The approximate size of the bird. Depending on the entry, this may be given as the length from beak-to-tail-tip, the wingspan, or the height when standing.

Diet: The most likely sources of sustenance for a species. As most birds are opportunistic feeders – varying their diet depending on the resources available – they may have a broader diet than the primary food source given in an entry. For example, while saffron toucanets eat primarily fruit, they occasionally raid other birds' nests for eggs, and eat insects and small lizards. As fruit makes up the majority of their sustenance, fruit is given as their diet in the entry.

Activity: The phase of the day in which the species is most active. Entries indicate the species is either diurnal (meaning a species is active primarily in the daytime) or nocturnal (referring to those species that are most active at night). Some individuals or subgroups – especially in urbanised areas where they are subject to light pollution – will defy these usual phases of activity.

Migration patterns: A description of the migration patterns – or lack of migration – for the species (e.g. Siberian cranes travel south over winter to breed in the Yangtze river basin, and retreat back north to the tundra over summer). Some species are termed nomadic, which means they do not follow a seasonal pattern of travel but will move location within an area depending on resource availability.

IUCN status: The species' population status as recorded by the International Union for Conservation of Nature (IUCN). The IUCN Red List of Threatened Species™ includes several categories, ranging from Least Concern (species with stable or increasing numbers), through increasingly diminished statuses: Near Threatened, Vulnerable, Endangered, Critically Endangered, Extinct in the Wild, and Extinct. These categories provide us with an understanding of how well a species is faring under current pressures.

Main description: Provides behavioural and ecological information about the species.

WHERE BIRDS LIVE (& WHERE TO SEE THEM)

While the words 'I'm going birdwatching' often conjure up images of a lengthy hike through a remote jungle, there are many local areas rich in bird species that require little physical or financial commitment to visit.

Try starting local! Get familiar with the birds you often see in your area. Nearby parklands and waterways close to you – particularly those close to or in the city – can often be accessed by public transport, are wheelchair accessible and are great places to start seeing a variety of birds. At the back of the book in Resources for Birdwatchers (*see* p. 112) you can find some suggestions for how to get started. The world map (*see* pp. xviii–xix) shows some of the primary regions where each species can be found. As you'll be able to see, featured bird species occupy distinctive ecosystems across the globe. The total distribution of each species can be found in their relevant entry.

local lakes, rivers, creeks,
streams and dams

seashores, boat ramps
and jetties

parks, golf courses, sports
grounds/ovals, botanic gardens
and well-planted/green suburbs

national and state parks
and campgrounds

any remnant patches of
older trees

farmland and irrigated
pastures

WORLD MAP

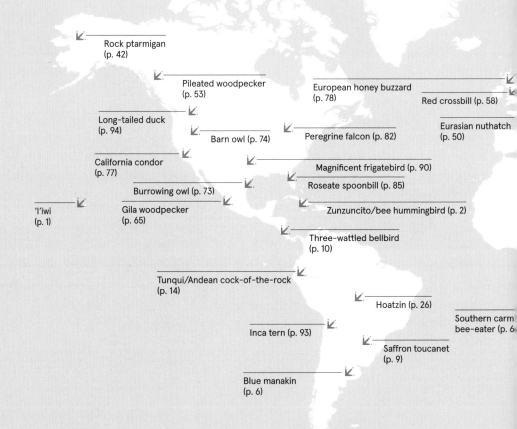

Rock ptarmigan (p. 42)

Pileated woodpecker (p. 53)

European honey buzzard (p. 78)

Red crossbill (p. 58)

Long-tailed duck (p. 94)

Barn owl (p. 74)

Peregrine falcon (p. 82)

Eurasian nuthatch (p. 50)

California condor (p. 77)

Magnificent frigatebird (p. 90)

Burrowing owl (p. 73)

Roseate spoonbill (p. 85)

'I'iwi (p. 1)

Gila woodpecker (p. 65)

Zunzuncito/bee hummingbird (p. 2)

Three-wattled bellbird (p. 10)

Tunqui/Andean cock-of-the-rock (p. 14)

Hoatzin (p. 26)

Southern carm bee-eater (p. 6

Inca tern (p. 93)

Saffron toucanet (p. 9)

Blue manakin (p. 6)

Adélie penguin (p. 98)

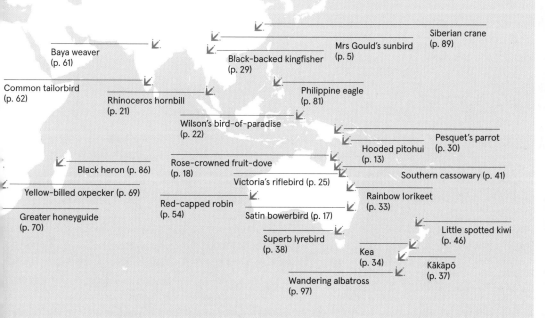

TIPS FOR BIRDWATCHING BEGINNERS

When you find yourself out and about – be it in the park, camping, making your way through the suburbs, at the river, beach, or on a road trip – encourage yourself to notice details of your surroundings. Birds are going to be around you, it's just a matter of reminding yourself to observe them. While a pair of binoculars will make things easier, even just watching from a distance can give you enough information to identify (and appreciate) a species you encounter.

When I spot a bird I'm unfamiliar with, I try to stand quietly and observe the bird for as long as I can, and I avoid going straight to a bird guide, as it usually distracts me from the bird itself. Instead, I like to soak in as much detail as possible at first glance. I take note of the general size and shape, then hone in on any distinguishing details. Does the bird have a short, blunt beak, or a long curved bill (*see* Appendix B, pp. 106–7)? A certain strip of coloured feathers in the tail or wings? A fluffy head? Or no feathers on the face at all? If the bird has been singing, I attempt to remember the tone or 'quality' of the call (whether it was rasping, glassy, or descending, for example), as this often helps immensely with identification. I repeat these details in my mind as I observe the bird, trying to gather as much information as I can, before I inevitably lose sight of it.

Usually then I will turn to a field guide, going by habitat, shape and general colour to find a relevant section. I then scan the birds that seem to be the most likely candidates by appearance, and make a little list of birds that are comparable (there may be a surprising number of similar-looking species you have to choose between). Using the details I noted whilst observing, I whittle down the options towards a particular species, typically by using geographic location (am I in the recorded range for that species? i.e. does the distribution map show that bird is usually seen in my area?). Another detail that helps immensely is habitat: does that bird frequent marshlands and silty floodplains, or does it prefer to hunt in alpine rivers? Additionally, many field guides will note peculiar behaviours a species may engage in that distinguish it (for example, male Baya weavers prepare for the breeding season by weaving elaborate hanging nests to impress a female mate). Other aspects that may help are a peculiar style of flight (for example, do they have short, 'bouncing' pulses of flight, or a soaring quality?) or a distinct silhouette in flight, such as a square-tipped tail or long forked tail-tips. (See Appendices C and D on pp. 108–9 and 110–1.)

Ideally, with these details gathered and taken into account, I will find an accurate description of the same bird in my guide. Success!

If you have a list, you can write down the species you have spotted (some people keep life lists, annual lists, and even daily lists), or if you're using an online database – such as eBird – you can add it to a personal checklist there.

A few pointers:

Patience – Often a bird will hop in and out of sight while you try and ID it. If you can't get a good look at the bird, try and hold steady for a minute or two, and it will likely shift into a better position. If you need to get a closer look, try moving slowly and quietly – chasing a bird between trees, or rapidly walking close to them will often scare them off. Keeping voices low also helps keep a bird at ease and hopefully allows you a longer look.

Listen – Bird song can prove a vital method for identifying a species. In some cases, the bird's call alone is the most accurate way to distinguish one species of bird from another. Despite the intimidating array of bird songs to learn, you'll be surprised how quickly you'll become familiar with the tone of different species – especially if you start spending more time outdoors and observing birds.

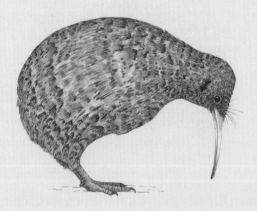

Put the sun at your back – Even the most distinctively coloured birds, such as the Southern carmine bee-eater (*see* p. 66), will look monotone if they are silhouetted by the sun. If you're able, try moving around a perch so that the sun is lighting up the bird, rather than shining from behind it.

Scan the flock - Often what looks like a mega-flock of a single species (e.g. Long-tailed ducks, *see* p. 94) will actually contain several distinctive species. Pay close attention to details when scanning a flock you encounter – you may be pleasantly surprised by a mix of species amongst the masses. By the same token, scanning reeds and grasses along shorelines often yields some bonus sightings of shy wading birds.

Head out in the morning or evening – The bookends of the day are oftentimes when birds are lower in trees and are more actively feeding. During the middle of the day (often the hottest part of the day), many birds will stick to thick, shady canopies and hideaways where they are much harder to spot.

A note on identifying birds of prey – Birds of prey can be frustratingly difficult to spot. You usually have to crane your neck to try to see distinguishing marks while the bird is silhouetted against the blue sky, and, confounding things even further, they are generally flying pretty high up. I find noting wing- and tail-shape are particularly useful for identifying these beautiful – but sometimes elusive – birds.

Take part in citizen science – Citizen science usually refers to logging observations of various phenomena to form a useful data pool for researchers to use. In the case of birdwatching, logging bird sightings on sites like eBird proves immensely useful for observing how bird populations, migration patterns, distribution and breeding seasons shift in response to environmental changes (e.g. urbanisation, logging).

A CAUTIONARY NOTE: BIRDING ETHICALLY

There have been many ethically questionable actions practiced by early birdwatching groups, including killing birds and collecting eggs as keepsakes. Though in modern birdwatching most of these practices have ceased, it is still important to be cautious while observing birds, to ensure you avoid endangering the very critters you're trying so hard to appreciate.

Pay attention to the behaviour of birds. If the bird (or birds) you are observing become agitated (e.g. swooping or harshly calling to try and get you to retreat), you are likely causing them stress, perhaps because a nest is close by. Parent birds will often defend nests and young to the point of damaging themselves. In those instances, retreat some distance to avoid stressing the bird. Also, avoid closely approaching or poking about in nests, and be aware that some species nest on the ground or amongst tall grasses where they may be hard to spot.

Don't flush birds out into the open. If you hear birds in undergrowth or in grasses, it is sometimes tempting to intentionally flush them into the open ('flush' is a term that refers to scaring a bird, either intentionally or unintentionally, which usually makes them flee). While this may allow you to get a clear glimpse of them, the birds must expend a fair amount of energy to flee, and causes the birds unnecessary stress.

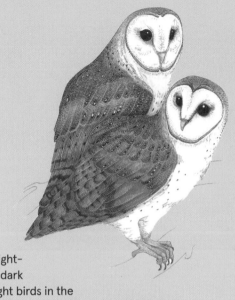

At night, avoid shining light directly at birds. Looking for owls (*see* pp. 72–3 and 74–5) and other night-birds may include heading out after dark with headlamps or torches to spotlight birds in the canopy. I recommend using a red filter on your light, as this dramatically reduces the disturbance night lights cause to wildlife. Try and avoid frying birds by leaving them in the spotlight for any lengthy period of time. Instead, try directing your light on to an adjacent branch, allowing a more diffuse light to spill onto the bird. Flash photography should also be avoided, day or night.

Look after the environment. There are several aspects to this: immediate (e.g. avoid disturbing habitat by sticking to better worn trails, leaving no trace), middle term (e.g. picking up litter where you encounter it, volunteering to weed invasive plants, or plant native vegetation in your local area) and longer term (helping others appreciate the beauty of wild spaces and biodiversity by sharing your passions, and by making steps to live in a more sustainable way, however small your contribution may be depending on personal circumstances). When we take responsibility for landscapes, and make efforts to foster biodiversity, we benefit as much as our fellow animals do.

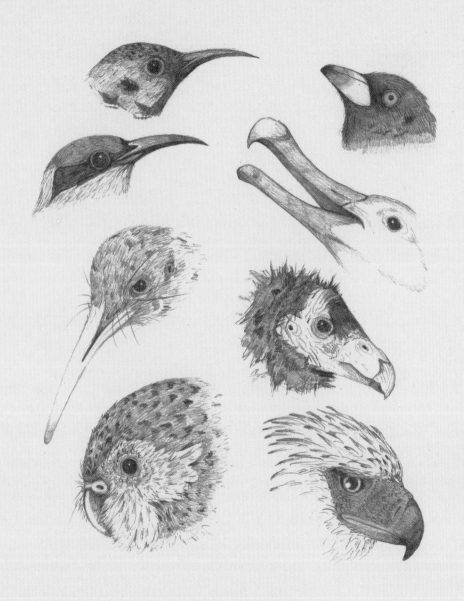

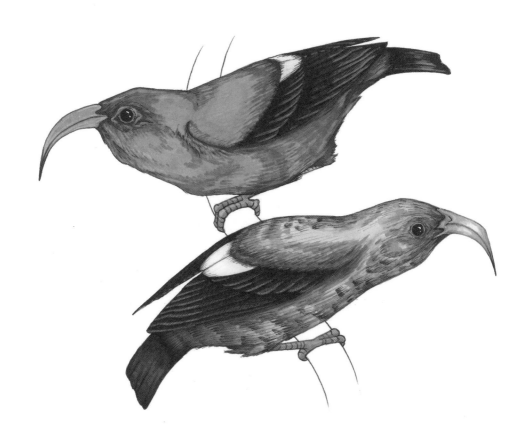

'I'IWI

Drepanis coccinea

DISTRIBUTION
Hawai'i

SIZE
15cm (6in)
beak-to-tail-tip

DIET
Nectar, insects
and spiders

ACTIVITY
Diurnal

MIGRATION PATTERNS
Non-migratory but will move
locally to seek food

IUCN STATUS
Vulnerable

Also known as the scarlet honeycreeper, the sugar-loving 'i'iwi (pronounced 'ee-ee-vee') has a long curved bill to help it drink nectar from deep tubular flowers. These birds spend their time furtively probing around the mountain-slope forests of their Hawaiian homelands, where they feed from flowers of 'ōhi'a lehua trees and lobeloid shrubs (snacking on the occasional insect as well). Despite their marvellously curved beaks, these birds are actually part of the finch family (Fringillidae), which usually have short, straight beaks. Many years of isolation have allowed 'i'iwis to coevolve with the unique tubular flowers that grow across the Hawaiian archipelago. In these tropical island forests, the 'i'iwis' lengthened beak pollinates the flowers they drink from, linking the fates of these birds and the plants they rely on.

ZUNZUNCITO/ BEE HUMMINGBIRD

Mellisuga helenae

DISTRIBUTION
Cuba

SIZE
6cm (2.4in)
beak-to-tail-tip

DIET
Nectar, insects
and spiders

ACTIVITY
Diurnal

MIGRATION PATTERNS
Non-migratory but will move
locally to seek nectar

IUCN STATUS
Near Threatened

Zunzuncitos – the smallest birds in the world (*see* Appendix A, pp. 104–5) – need to constantly drink nectar to sustain their high-powered lifestyle. They aren't much bigger than the bees that vie with them for nectar. Despite being so delicate, they are sensational fliers, regularly visiting more than a thousand flowers in a single day of feeding, pollinating as they go. These impossibly tiny creatures can beat their wings around 80 times a second, allowing them to accurately dart to and from flowers. Like all hummingbirds, zunzuncitos fly in a more vertical position than other birds, twisting their wings in a figure eight to create lift. This amazing technique allows them to perform incredible feats, including hovering and even flying backwards.

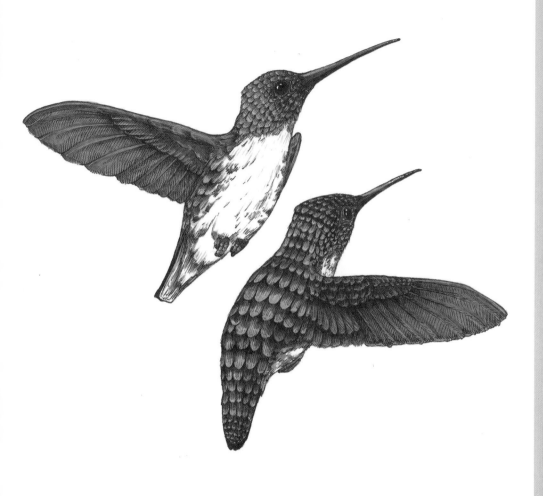

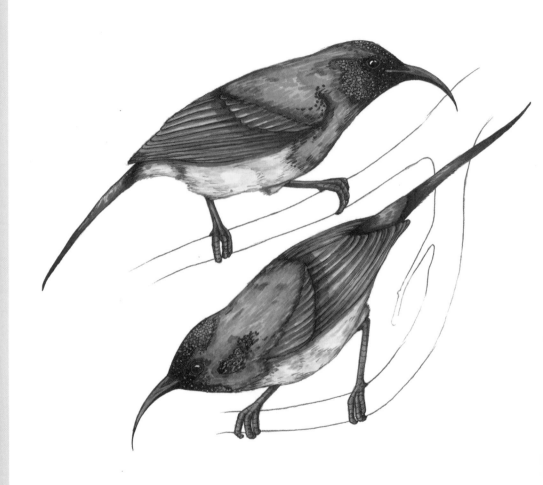

MRS GOULD'S SUNBIRD

Aethopyga gouldiae

DISTRIBUTION
Asia & Southeast Asia

SIZE
11cm (4.5in)
beak-to-tail-tip

DIET
Nectar, insects
and spiders

ACTIVITY
Diurnal

MIGRATION PATTERNS
Non-migratory but will
move locally to seek food

IUCN STATUS
Least Concern

Mrs Gould's sunbirds are in a family of birds known for their proclivity for spider catching (Nectariniidae). These seemingly delicate birds are very effective spider hunters, catching them, eating them, and weaving their silken webs into their nests. While they are adept at tackling spiders, they also supplement their diet by drinking nectar from tubular flowers. They have a long, bifurcating tongue that helps them to draw nectar from flowers by capillary action. By habitually sipping nectar, these birds are effective pollinators in the forests and orchards where they congregate in groups of eye-catching plumage. This vibrant species was named for Elizabeth Gould, a renowned artist in the 1800s who contributed illustrations to Charles Darwin's publications.

BLUE MANAKIN

Chiroxiphia caudata

DISTRIBUTION
South America

SIZE
15cm (6in)
beak-to-tail-tip

DIET
Fruit, insects and
other invertebrates

ACTIVITY
Diurnal

MIGRATION PATTERNS
Non-migratory

IUCN STATUS
Least Concern

Like a gentlemanly dance troupe, complete with red caps and azure bolero jackets, blue manakins (also known as swallow-tailed manakins) go to great lengths to woo a mate. While female blue manakins are a sensible, well-camouflaged green colour, the males are built for ostentation in their vivid blue plumage. These amazing little birds collaborate to seduce a mate, acting as a coordinated dance crew to convince a female that one of them is worthy as a partner. The troupe gathers on a branch, and proceeds to hop in a windmill-like circuit over one another, complete with chirps, fluttering, and hovering displays. These birds practice well before reaching adulthood, perfecting their performance by gathering in juvenile troupes.

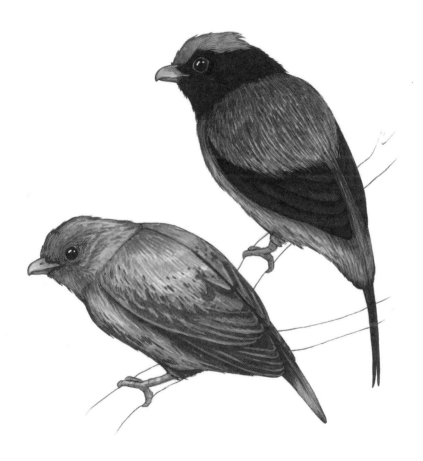

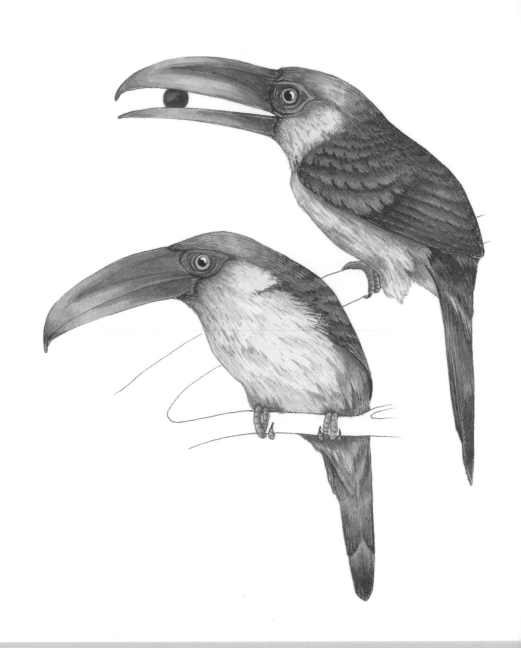

SAFFRON TOUCANET

Pteroglossus bailloni

DISTRIBUTION
South America

SIZE
35cm (14in)
beak-to-tail-tip

DIET
Fruit

ACTIVITY
Diurnal

MIGRATION PATTERNS
Non-migratory, though
may move nomadically
to seek ripe fruit

IUCN STATUS
Near Threatened

Also known as banana toucans, these gloriously yellow birds live in the lush forests of eastern South America. Their huge bills are used for feeding on juçara and other palm fruits. When the fruit is swallowed, the seed is de-fleshed in the stomach, then – most often – the undigested seed is regurgitated, though it may sometimes pass through the entire digestive tract. These de-pulped seeds have an improved germination rate, as they have undergone some scarification in the gut of the toucanet, weakening the seeds' hard exterior. They also have often been flown to a new area of forest where, after being disgorged by the toucanet, they have a good chance of getting established. As seed dispersers, saffron toucanets are important to the future of their habitual forests as they maintain the very plants that sustain them.

THREE-WATTLED BELLBIRD

Procnias tricarunculatus

DISTRIBUTION
Central America

SIZE
27cm (10.5in)
beak-to-tail-tip

DIET
Fruit

ACTIVITY
Diurnal

MIGRATION PATTERNS
Migrates to highland areas for
breeding, and retreats downslope
again, with movements depending
on habitat and food availability

IUCN STATUS
Vulnerable

The three-wattled bellbird is more often heard than seen, as they have one of the loudest calls in the world – an ear-piercingly loud, metallic 'bonk'. They thrive in rainforests where they can access a hearty supply of fruit as sustenance. Male three-wattled bellbirds gather to perform in open, well-lit areas of forest (known as leks), often on bare branches or dead trees. The birds hop from branch to branch, making territorial 'bonk' calls to garner attention from females. During these seasonal gatherings, the three-wattled bellbirds pass most of the consumed fruit seeds in areas of forest that are open, well-lit and sparsely vegetated. Similarly to their relatives, the Andean cock-of-the-rock (*see* pp. 14–5), this behaviour increases the survival rate of the seeds past germination, contributing to forest regeneration.

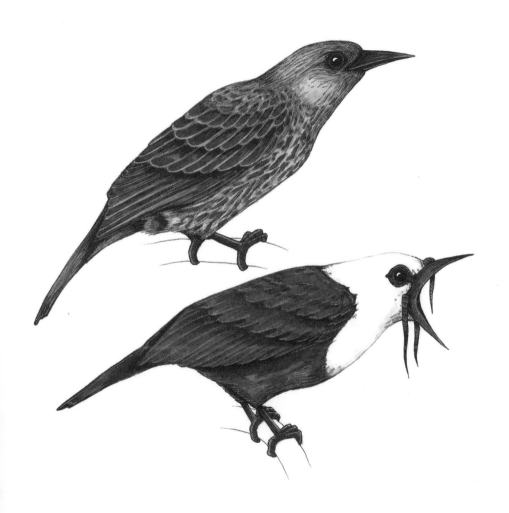

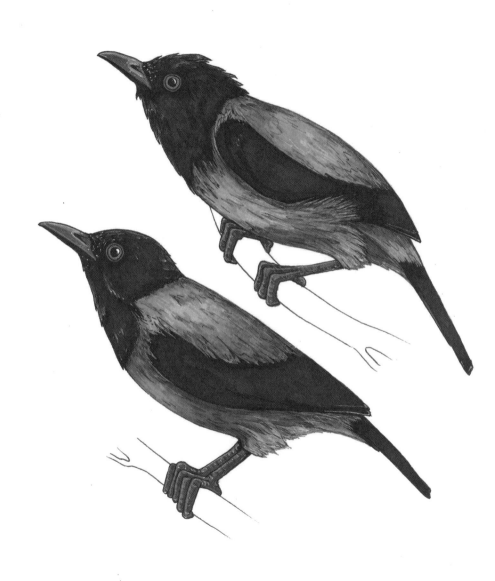

HOODED PITOHUI

Pitohui dichrous

DISTRIBUTION
West Papua, Papua &
Papua New Guinea

SIZE
22 cm (8.5in)
beak-to-tail-tip

DIET
Fruit, insects and
other invertebrates

ACTIVITY
Diurnal

MIGRATION PATTERNS
Non-migratory

IUCN STATUS
Least Concern

The beautiful-but-seemingly-innocuous hooded pitohuis have garnered a fair bit of scientific attention, because – rather like some species of salamanders, frogs and toads – these birds are poisonous. Boisterously moving in groups across the rain-forested slopes of the Papua region, hooded pitohuis have poisonous tissues, skin and feathers. The toxin they exude – a nervous-system-affecting poison known as batrachotoxin – causes a burning discomfort if contact is made with skin, an effect which can last for several hours. This toxicity was discovered when scientists experienced numbness and pain in their hands after holding these birds during field research. The hooded pitohuis have acquired a resistance to these toxins, which they bioaccumulate from certain aspects of their diet. This poison likely offers them some protection from predators and parasites.

TUNQUI/ANDEAN COCK-OF-THE-ROCK

Rupicola peruvianus

DISTRIBUTION
South America

SIZE
30cm (12in)
beak-to-tail-tip

DIET
Fruit, insects and
other invertebrates

ACTIVITY
Diurnal

MIGRATION PATTERNS
Non-migratory

IUCN STATUS
Least Concern

The coiffed, fluffy Andean cock-of-the-rock (also known by its Quechua name tunqui) is seen in glimpses of vibrant orange through the misty cloud forests of the South American mountains. The males of this species are well-known for gathering in groups to dance and make wheezy, growling calls in the hopes of catching the interest of nearby females. They tend to gather in more open areas of rainforest (known as leks), where the light is best for showing off their frenzied dance moves. Like other cotingas – such as the Three-wattled bellbird (*see* pp. 10–1) – the Andean cock-of-the-rock plays a role in revegetation by dispersing fruit seeds in open areas of forest. After mating, females build a nest of mud and forest debris in the hollows of rocky cliffs, earning them the name 'cock-of-the-rock'.

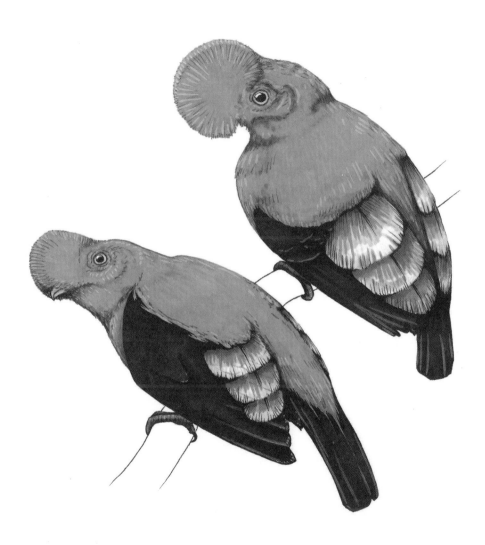

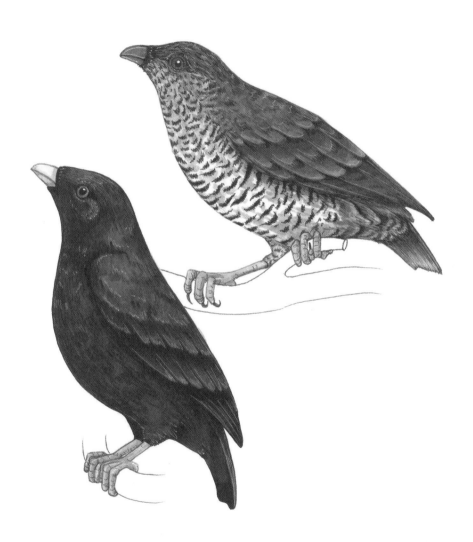

SATIN BOWERBIRD

Ptilonorhynchus violaceus

DISTRIBUTION
Australia

SIZE
25cm (10in)
beak-to-tail-tip

DIET
Insects, fruit
and foliage

ACTIVITY
Diurnal

MIGRATION PATTERNS
Satin bowerbirds return to the same
areas to breed every spring, then
disperse into open woodlands and
orchards over the cooler months

IUCN STATUS
Least Concern

Satin bowerbirds must have one of the most entrancingly peculiar methods of seduction in the birding world. Male satin bowerbirds – a rich, midnight blue colour at full maturity – embark on a large architectural project in the lead up to breeding season: they must produce a bower. This is comprised of two 'walls' of twigs carefully propped upright to form a little avenue in which the bowerbird can perform. They then decorate their construction with any number of trinkets, including stones, feathers, shells and plastic waste. They especially prefer blue objects – often blue bottle caps – which are frequently stolen from fellow males who are trying to construct their own bower. When they have perfected their masterpiece, they call in nearby females through hissing and mimicry. If a female is impressed with a male's dancing and his bower, she will choose to mate with him.

ROSE-CROWNED FRUIT-DOVE

Ptilinopus regina

DISTRIBUTION
Southeast Asia &
Australia

SIZE
20cm (8in)
beak-to-tail-tip

DIET
Fruit

ACTIVITY
Diurnal

MIGRATION PATTERNS
Some birds of this species migrate
southwards in summer, while
others remain resident year round

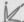

IUCN STATUS
Least Concern

These shy, fruit-loving doves live in dense rainforests and woodlands, where they gorge themselves on all manner of fruits, including those of figs, palms, giant pepper vines and camphor laurel trees. Due to their secretive nature, birdwatchers often pinpoint the location of rose-crowned fruit-doves not by their calls, but by the sound of fruit dropping to the ground where they are feeding. To further hide themselves, these birds opt to sip water from canopy leaves where it collects as rainfall or dew, rather than going to the ground to drink. Because fig species fruit asynchronously (at different times across the year), they are an important ongoing food source for the rose-crowned fruit-dove. However, as habitat loss has continued across their range, pest species of camphor laurel have become prominent in the doves' diet. These stealthy, bashful birds traverse large tracts of forest in search of fruit, and thus act as seed dispersers in their habitat.

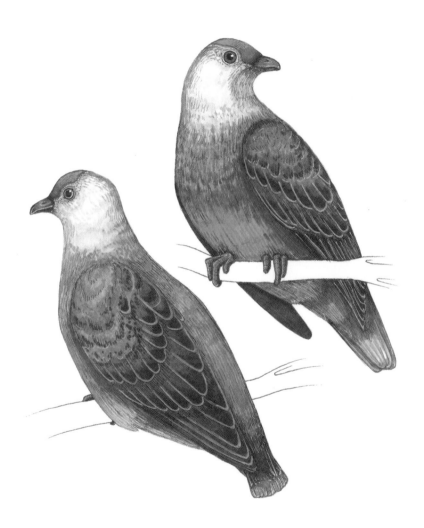

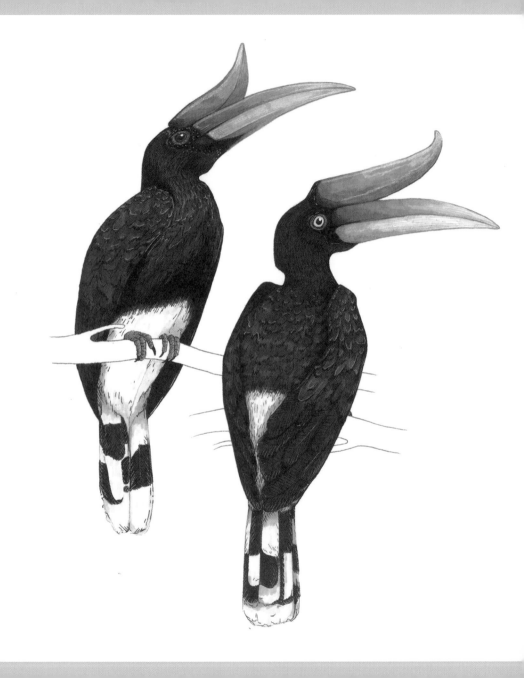

RHINOCEROS HORNBILL

Buceros rhinoceros

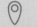

DISTRIBUTION
Southeast Asia

SIZE
80cm (31in)
beak-to-tail-tip

DIET
Fruit, insects, lizards
and eggs

ACTIVITY
Diurnal

MIGRATION PATTERNS
Non-migratory

IUCN STATUS
Vulnerable

Looking as if they emerged from the mists of the Earth's past, the huge rhinoceros hornbills of the Southeast Asian rainforest spend most of their life eating fruit in tree canopies. These birds – assisted by their striking beaks – are capable of consuming seeds that are larger in diameter than most other frugivorous birds. They either regurgitate large seeds after their stomach has removed the sugary flesh, or the seeds pass through the digestive tract and end up back on the forest floor. Hornbills are sometimes referred to as 'forest farmers' because they traverse large tracts of forest to pursue ripening fruits, dispersing seeds as they go and helping to regenerate the forest. When it comes time to breed, they lay eggs in tree hollows, which they must defend against other animals, including fellow hornbills, king cobras and monitor lizards.

WILSON'S BIRD-OF-PARADISE

Cicinnurus respublica

DISTRIBUTION
Raja Ampat
archipelago,
New Guinea

SIZE
21cm (8.5in) (male)
16cm (6.5in) (females)
beak-to-tail-tip

DIET
Fruit, insects and
other invertebrates

ACTIVITY
Diurnal

MIGRATION PATTERNS
Non-migratory

IUCN STATUS
Near Threatened

Male Wilson's birds-of-paradise put on elaborate courtship displays to attract mates, using a finely tuned routine to show off their prowess and hopefully win a partner. First, the resplendent males begin by industriously clearing a patch of forest floor where light reaches, creating a stage to best show off their colours. Then they call loudly to draw in a female, and coax her to perch above them to watch. Then, like a dancing Picasso painting, the male birds show a spectacular array of colours as they move: purple legs, scarlet back, gold shoulders and luminous blue skull-cap – even the inside of their mouth is a vivid yellow. The part that takes the cake, however, is the dazzling, iridescent green throat feathers (known as a pectoral shield), which they flash to the females in the coup de grâce of their performance.

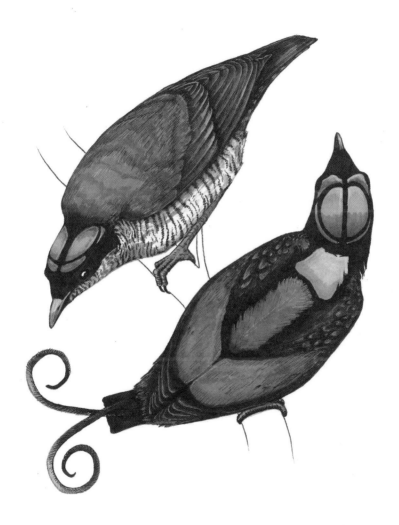

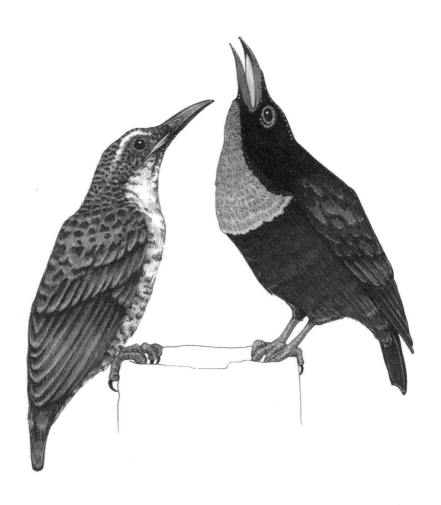

VICTORIA'S RIFLEBIRD

Ptiloris victoriae

DISTRIBUTION
Australia

SIZE
24cm (12in)
beak-to-tail-tip

DIET
Fruit, insects and
some nectar

ACTIVITY
Diurnal

MIGRATION PATTERNS
Non-migratory

IUCN STATUS
Vulnerable

Like veritable Casanovas of the Atherton Tablelands, male Victoria's riflebirds have one mission in life: woo as many females as they can. Donned in velveteen black feathers, with a lustrous chest patch and a bright yellow mouth, the showy males choose high stumps as their stage, where they are visible from all angles. Poised here, they must call in females to join them in their dance. When a female approaches, the male flourishes his wings from side to side, and stretches his neck upright to display his chest feathers. The female, if won over by this display, will slowly creep closer (or allow the male to move closer) until she is within the embrace of his wings. Male riflebirds don't take part in parental care, but instead, spend all their energy on this complex courtship display. This dancing ritual is so essential, juvenile male riflebirds start practising well before they develop adult plumage, sometimes rehearsing with one another in private (rather like Blue manakins, *see* pp. 6–7).

HOATZIN

Opisthocomus hoazin

DISTRIBUTION
South America

SIZE
65cm (25in)
beak-to-tail-tip

DIET
Foliage

ACTIVITY
Diurnal

MIGRATION PATTERNS
Non-migratory

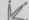

IUCN STATUS
Least Concern

Placed in its own exclusive order of birds (Opisthocomiformes), the hoatzin is, taxonomically speaking, the loneliest bird in the world. These unusual creatures live in the rainforests of the Amazon, where they clamber through the thick foliage, feeding on leaves. To assist with their fibre-rich diet, they have a specialised ruminant-style digestive system, in which bacteria in their crop (a food storage pouch below the esophagus) help to break down tough plant fibres (called lignins). This fermentation causes them to emanate a smell like cow poo, earning them the moniker 'stinkbirds'. When breeding, parents most often build nests in tree canopies overhanging a river. If threatened, hoatzin chicks will drop from the canopy into the water, where they can dive out of reach. Unusually, these clever chicks have a further ace up their sleeve: they are born with a claw on the joint and tip of each wing, which they can use to clamber back up from the water to rejoin their family in the nesting tree.

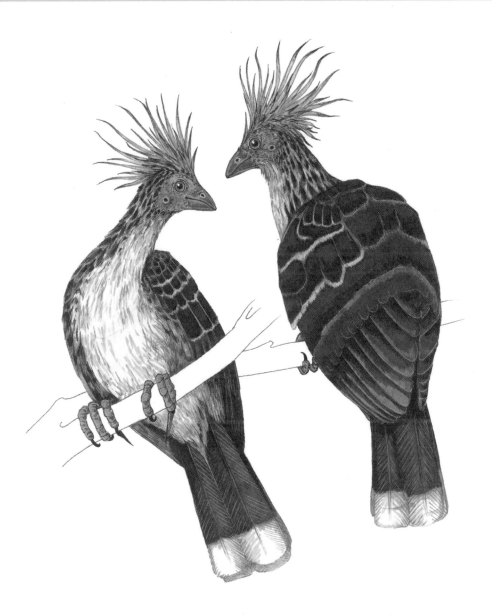

BLACK-BACKED KINGFISHER

Ceyx erithaca

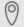

DISTRIBUTION
Indian subcontinent
and Southeast Asia

SIZE
13cm (5in)
beak-to-tail-tip

DIET
Insects, spiders, crustaceans
and water-dwelling vertebrates
(e.g. fish, frogs, lizards)

ACTIVITY
Diurnal

MIGRATION PATTERNS
Partially migratory –
northernmost birds will
migrate further south in winter

IUCN STATUS
Least Concern

Black-backed kingfishers are supremely patient hunters, often perching on a branch over water where they watch and wait for movements of aquatic critters. When they sight prey, they gracefully dive, then return to their perch with a catch in their bill. Like other kingfishers, they have excellent eyesight, with two fovea per eye (a fovea is a component of the eye that allows for sharp vision – humans have only one). With their pinpoint eyesight, fastidious dive control and sword-like beak, these tiny birds are formidable hunters. When breeding, a pair nests in a long burrow dug into a river bank, or will occupy an existing hole made by other creatures. Black-backed kingfishers serve as an indicator species, as they rely on healthy riverine ecosystems for survival.

PESQUET'S PARROT

Psittrichas fulgidus

DISTRIBUTION
West Papua, Papua &
Papua New Guinea

SIZE
45cm (18in)
beak-to-tail-tip

DIET
Figs

ACTIVITY
Diurnal

MIGRATION PATTERNS
Non-migratory, though will
move nomadically to follow
figs as they ripen

IUCN STATUS
Vulnerable

Also known as the Dracula parrot, this regal creature is an enigmatic species that lives in the rainforested mountains of New Guinea island. Despite their vampiric outfits, these parrots are actually gentle frugivores – they love rainforest figs, though they will occasionally eat other flowers too. Their sharp, powerful beaks easily break through the tough skin of figs, allowing them to feast on the sugary interior. In a generous accident, many other rainforest birds with less tough beaks gather to consume the open fig remnants left by feeding Pesquet's parrots. Often assembling in pairs or sometimes in larger groups, these birds use tree hollows as nesting sites.

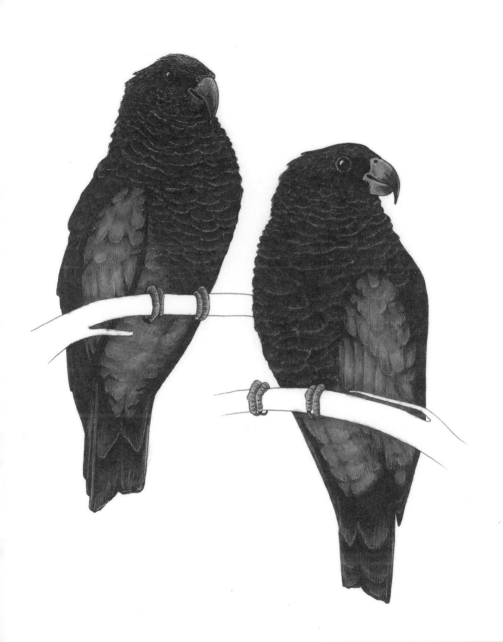

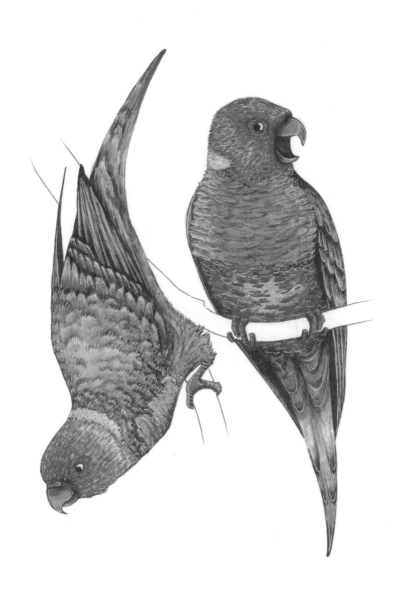

RAINBOW LORIKEET

Trichoglossus moluccanus

DISTRIBUTION
Australia

SIZE
25cm (10in)
beak-to-tail-tip

DIET
Nectar, fruit and flowers

ACTIVITY
Diurnal

MIGRATION PATTERNS
Non-migratory but
shift nomadically in
pursuit of food

IUCN STATUS
Least Concern

You may think such a superbly coloured animal would be delicate in nature, but these cheeky lorikeets spend their time screeching, chasing other birds and guzzling nectar from flowering gum trees. Like a group of toddlers on a sugar rush, rainbow lorikeets are as raucous as they are colourful, hanging out in big gossiping flocks. These boisterous parrots primarily love flower nectar, but will also eat whole blossoms, and fruit (off your precious fruit trees). They especially love nectar-rich eucalyptus flowers, but will readily take advantage of any sugar source. Like all lorikeets, they have a specialised brush-tipped tongue that helps them to lap up nectar with supreme efficiency. When it comes time to breed, they nest in tree hollows.

KEA

Nestor notabilis

DISTRIBUTION
Aotearoa
New Zealand

SIZE
47cm (18.5in)
beak-to-tail-tip

DIET
Fruit, nectar, roots
and carrion

ACTIVITY
Diurnal

MIGRATION PATTERNS
Non-migratory, though may
move to lower altitudes
over winter

IUCN STATUS
Endangered

On one trip to Aotearoa New Zealand, I went to Arthur's Pass in hopes of sighting the famous kea parrot, an alpine species renowned for its beautiful colours and intelligence. Instead of seeing a magnificent parrot soaring over the snow-capped mountains, my encounter with a kea was instead watching it lurk down the main street of a nearby township, testing out the rubber tyres of parked cars with its sharp beak. These wily parrots are well known for haranguing mountain towns, where they seek scraps, entertainment or a combination of the two. When not finessing their way into trash cans, kea traverse the mountain tops and southern beech forests of the south island of Aotearoa New Zealand in small groups (known as 'circuses'). Kea are strong fliers, able to cover long distances across mountain ranges, dispersing seeds as they travel.

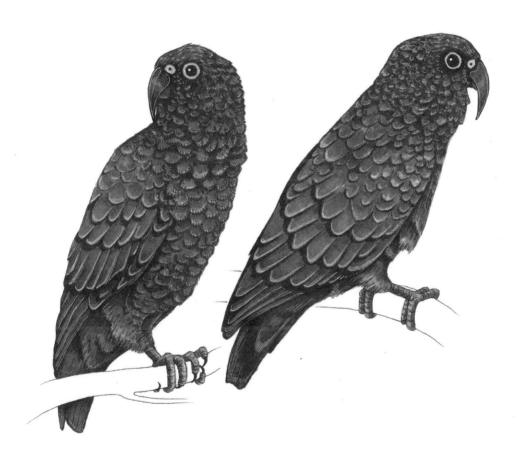

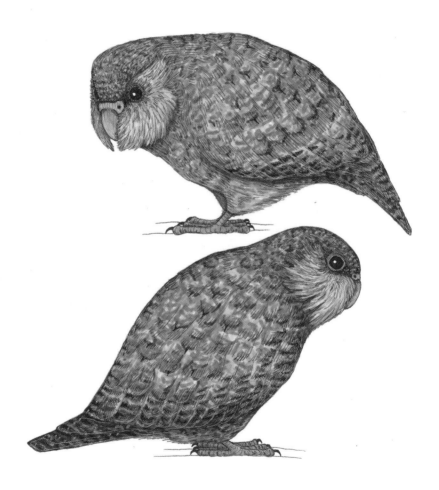

KĀKĀPŌ

Strigops habroptilus

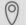

DISTRIBUTION
Aotearoa
New Zealand

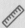

SIZE
60cm (23.5in)
beak-to-tail-tip

DIET
Fruit (especially that
of rimu plants)

ACTIVITY
Nocturnal

MIGRATION PATTERNS
Non-migratory

IUCN STATUS
Critically Endangered

Rather like an adorable, vaguely bird-shaped pile of moss, these nocturnal, flightless birds – also known as owl parrots – have to be one of the most endearingly clumsy birds in the world. Trundling on foot through Aotearoa New Zealand's island forests, kākāpōs can feed on a range of plants and their fruits, but have a particular love for rimu, a type of conifer tree. These trees tend only to fruit in abundance every four years or so, and, as a result, kākāpōs tend only to breed during these times of abundance. Due to low reproduction rates, introduced pest species and habitat loss in Aotearoa New Zealand, these parrots declined in numbers until they were thought nearly extinct in the wild during the 1950s. With great conservation efforts, their numbers have slightly rebounded, though they are now found only on predator-free offshore islands where they are closely managed.

SUPERB LYREBIRD

Menura novaehollandiae

DISTRIBUTION
Australia

SIZE
60cm (24in)
beak-to-tail-tip

DIET
Insects and other
invertebrates

ACTIVITY
Diurnal

MIGRATION PATTERNS
Non-migratory

IUCN STATUS
Least Concern

Both male and female superb lyrebirds can imitate other bird calls – sometimes a whole crowd of birds at once – with incredible accuracy. Male lyrebirds have an ornate tail of patterned feathers, which they can curl over themselves like a wedding veil. Posed thus, they dance and sing the songs of other bird species to capture the attention of female lyrebirds. Raising the young alone, females build elaborate, cave-like nests in which to house a single, charcoal-black egg. To defend their nests, they often imitate the calls of predatory animals. Superb lyrebirds forage through immense amounts of soil and leaf litter while searching for grubs and insects to feed on. As a result, these birds are considered 'ecosystem engineers' as they contribute to nutrient recycling and prevent soil compaction in southeastern Australian forests.

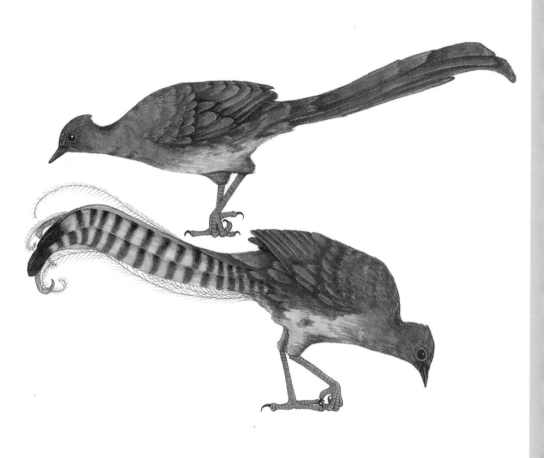

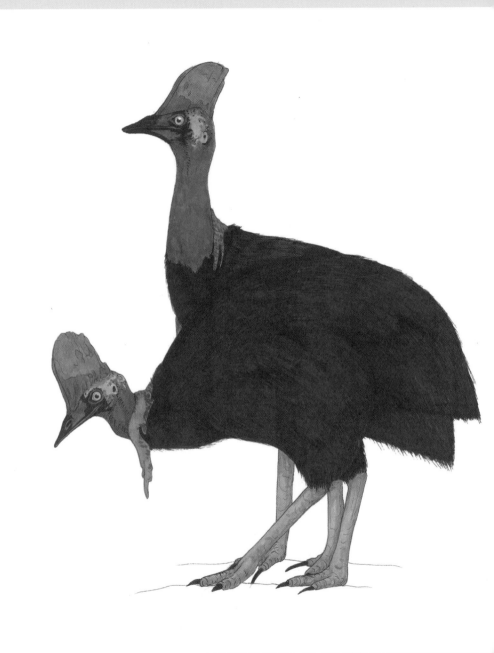

SOUTHERN CASSOWARY

Casuarius casuarius

DISTRIBUTION
Far Southeast Asia &
Northern Australia

SIZE
160cm (63in)
tall

DIET
Fruit, insects and
other invertebrates

ACTIVITY
Diurnal

MIGRATION PATTERNS
Non-migratory but will
forage over large areas

IUCN STATUS
Least Concern

Standing almost eye-level with most humans, the southern cassowary is an intimidatingly large creature (*see* Appendix A, pp. 104–5). Complete with huge claws (including an elongated defensive claw on the inner toes), a casque (the prominent fan on top of the head), and two bright wattles on the neck, these birds have to be one of the most conspicuously dinosaur-like species of modern Earth. Despite their fearsome appearance, southern cassowaries are actually fruit-lovers, consuming both a large volume and variety of rainforest fruits (though they particularly love the fruits of Davidson's plum and cassowary satinash). Due to their diet and the long distances they travel foraging, they disperse seeds widely, making them a keystone species, an essential contributor to the regeneration of tropical forests.

ROCK PTARMIGAN

Lagopus muta

DISTRIBUTION
Northern regions
of Europe, Asia
& America

SIZE
34cm (13in)
beak-to-tail-tip

DIET
Willow shoots, berries,
flowers and insects

ACTIVITY
Diurnal

MIGRATION PATTERNS
Non-migratory but may shift to
lower altitudes during winter

IUCN STATUS
Least Concern

Consummate alpine survivalists, these seemingly delicate birds are one of the only animals tough enough to live year-round on the harsh, icy mountain summits of the northern latitudes. Rock ptarmigans largely remain above the tree line through all four seasons, where temperatures regularly drop well below zero and harsh winds blow day and night. In winter, as the snow begins to fall, these birds moult into pure white plumage, allowing them to become near-invisible against the snowy backdrop. Their specialised feathers – present even on their feet and eyelids – act as an effective insulating layer against the cold. To protect themselves on icy nights, rock ptarmigans dig little snow hollows where they tuck themselves away on the lee side of the windy mountain slopes to preserve body heat. In spring, they moult into brown plumage, which camouflages them against the rocky mountain summits after the snow melts.

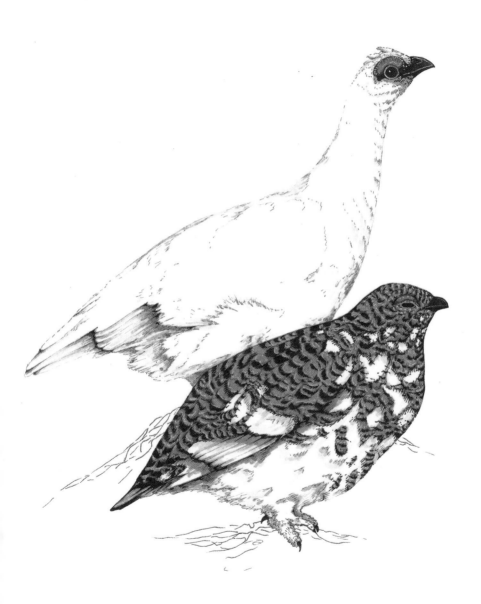

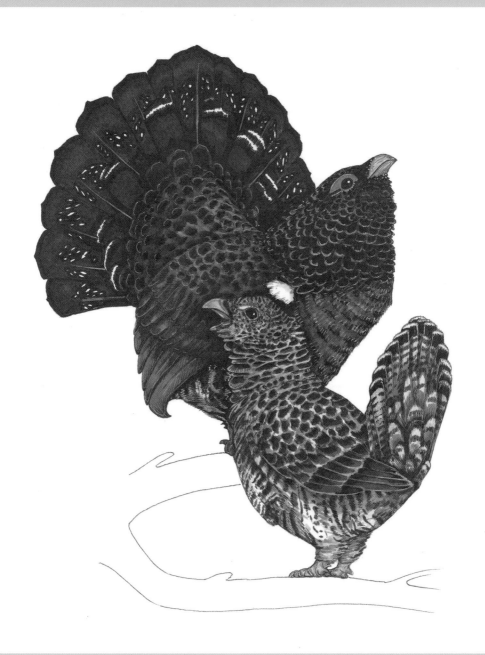

WESTERN CAPERCAILLIE

Tetrao urogallus

DISTRIBUTION
Northern Europe

SIZE
80cm (31.5in) (males)
60cm (23.5in) (females)
beak-to-tail-tip

DIET
Small shrubs, fruits
and insects

ACTIVITY
Diurnal

MIGRATION PATTERNS
Non-migratory

IUCN STATUS
Least Concern

When the breeding season begins in spring, male capercaillies grow bold, emerging from between the pine and spruce trees of the taiga (coniferous forests of the subarctic region). Stalking across the forest floor, they undergo an elaborate courtship display to attract a mate, raising their head and fanning out their enormous, dark tail. They emit a very eerie call – a bit like a creaky door in an old house – a sound that feels somehow fitting in the ancient forests they call home. The name 'capercaillie' is an adaptation of a Scottish word meaning 'horse of the wood', and, appropriately, these large birds spend most of their lives grazing on various heath species (especially bilberry plants) that thrive in the pine-needle carpeted floors of the forest. When other food is scarce, these birds supplement their diet with pine needles, also consuming small stones (gastroliths) which sit in their stomachs to help break down plant fibres.

LITTLE SPOTTED KIWI

Apteryx owenii

DISTRIBUTION
Aotearoa New Zealand
(in predator-free
sanctuaries)

SIZE
25cm (10in) tall

DIET
Soil-dwelling
invertebrates

ACTIVITY
Nocturnal (though they
may be active during
daylight hours in predator-
free sanctuaries)

MIGRATION PATTERNS
Non-migratory

IUCN STATUS
Near Threatened

Kiwis have evolved so far from 'typical' birds they have almost become honorary mammals, complete with whiskers, hair-like feathers, and marrow-filled bones (most birds have hollow bones). They are also flightless, though they do have tiny vestigial wings, mostly hidden by their shaggy feathers. The little spotted kiwi is nearly sightless, instead relying on touch and smell for navigation and survival. Their clawed feet allow them to turn over the soil and loosen it before probing with their long, soft, and highly sensitive beak in search of food. They live in the forests and scrublands of Aotearoa New Zealand, nesting in burrows in the ground. Though they once spread across the north and south islands, the little spotted kiwi is now found exclusively in predator-free sanctuaries, where they are protected from introduced species (e.g. stoats) and habitat destruction.

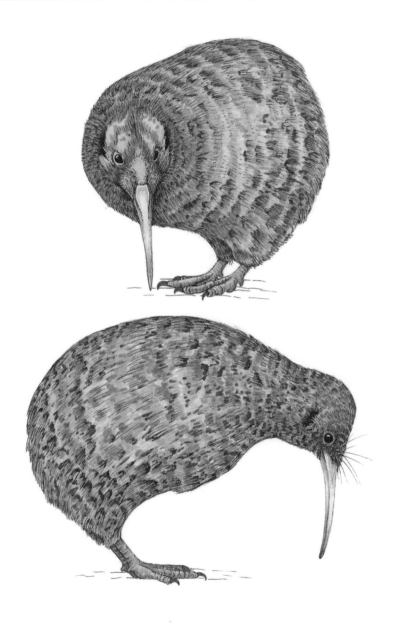

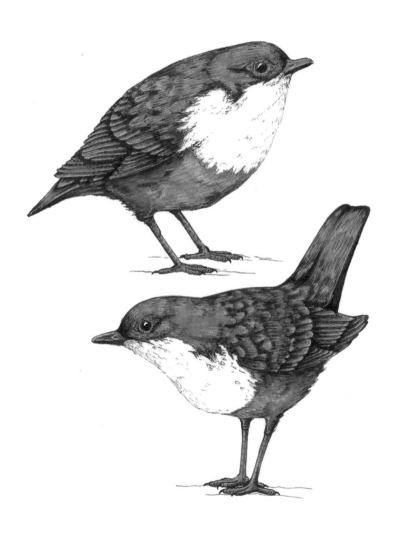

WHITE-THROATED DIPPER

Cinclus cinclus

DISTRIBUTION
Europe, northern
Africa & Asia

SIZE
18cm (7in)
beak-to-tail-tip

DIET
Aquatic invertebrates
(insects, snails), small fish
and small amphibians

ACTIVITY
Diurnal

MIGRATION PATTERNS
Largely non-migratory, though
some portions of the population
shift south over winter

IUCN STATUS
Least Concern

Perching on low branches and rocks near flowing water, white-throated dippers sing a sweet, warbling, wren-like song that mingles with the sound of the rivers they frequent. To seek food, the charming white-throated dippers use a surprising tactic: swimming. Seeking out caddisfly larvae and other water-dwelling invertebrates, these snowy-breasted birds skilfully wade and dive through icy waters, fully submerging themselves in pursuit of snacks. While at first glance they look like large, handsome wrens, to see them disappear under the surface and leave a trail of bubbles to mark their underwater flight is both surreal and wonderful. To further add to their endearing quality, they have a characteristic 'bobbing' motion to their perching behaviour, dipping themselves up and down as they scan their surrounds.

EURASIAN NUTHATCH

Sitta europaea

DISTRIBUTION
Europe & Asia

SIZE
14cm (5.5in)
beak-to-tail-tip

DIET
Insects, hazel fruits,
beech seeds

ACTIVITY
Diurnal

MIGRATION PATTERNS
Non-migratory

IUCN STATUS
Least Concern

Living in sheer defiance of gravity, the Eurasian nuthatch is a rather remarkable creature. One of the only bird species that easily climbs head-first *down* a tree trunk, these energetic birds dart across, up and down trees, foraging for invertebrates amongst the bark. Feeding primarily in mixed forests of oak, chestnut and other old growth trees, nuthatches are resourceful – they are known to use slivers of wood to pry up bark in search of invertebrates. These clever birds also cache food by tucking gathered seeds into crevices in trees, using plant and lichen debris to conceal their supplies. These food stores are then used to tide the nuthatch over if food becomes scarce during the harsh winter season.

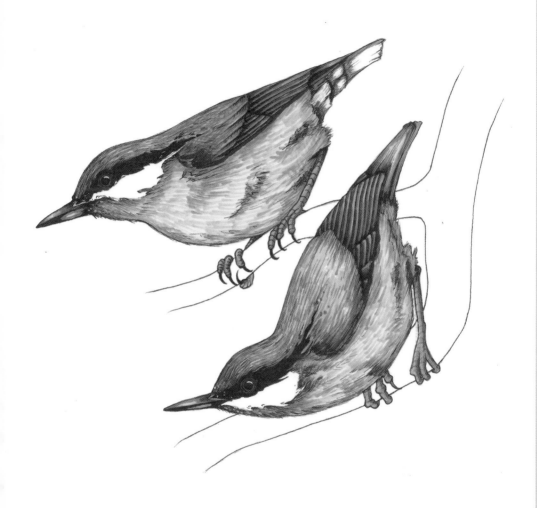

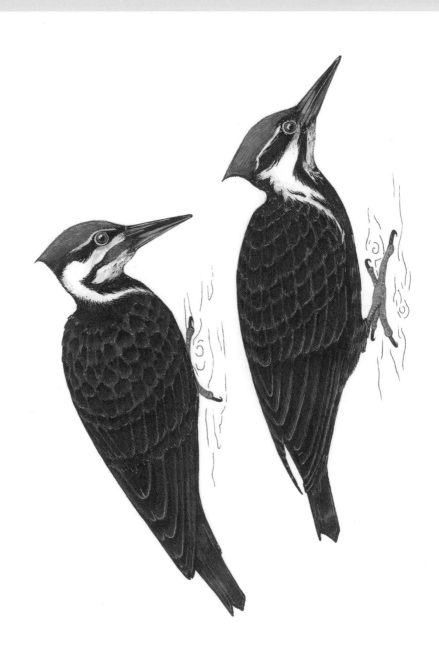

PILEATED WOODPECKER

Dryocopus pileates

DISTRIBUTION
North America

SIZE
45cm (17in)
beak-to-tail-tip

DIET
Invertebrates
(e.g. carpenter ants,
grubs and beetles)

ACTIVITY
Diurnal

MIGRATION PATTERNS
Non-migratory

IUCN STATUS
Least Concern

Pileated woodpeckers, like other woodpeckers, drill a nesting cavity in a dead or fungi-damaged tree. Every year, pileated woodpeckers use their strong feet to cling vertically to trunks and drill with enormous force into hardwood trees to form their arboreal homes, in which they raise their chicks. Like all woodpeckers, this species relies on its modified tongue (hyoid) bone, which encircles the brain, cushioning it from the impacts of drilling. They are the largest species of woodpecker in North America, and are revered as a keystone species in deciduous forests. As the pileated woodpecker drills a new nest each season, it frees up the old nesting cavity for use by other species of birds and even some mammals, causing a ripple effect through the ecosystem.

RED-CAPPED ROBIN

Petroica goodenovii

DISTRIBUTION
Australia

SIZE
11cm (4.5in)
beak-to-tail-tip

DIET
Invertebrates (insects
and spiders)

ACTIVITY
Diurnal

MIGRATION PATTERNS
Southern portions of the
population tend to move to
lower altitude areas over winter

IUCN STATUS
Least Concern

Though seemingly delicate birds, red-capped robins prove to be fierce defenders of their territory. During breeding season, they meet at territorial boundaries to perform a show-down. Some of these 'battles' are more dancing than fighting, mostly involving chest-puffing and hopping back and forth, all while twittering furiously. In other cases, territorial fights may come to severe blows, with males wounding their aggressors, or, more rarely, fighting to the death. These steadfast birds perch on bare branches, fences or rocky outcrops amongst mulga and cypress dominated landscapes, calling brightly. When not caught up in breeding season politics, red-capped robins happily move around in mixed-species flocks, forming merry, chirping groups alongside other small Australian birds, such as thornbills, woodswallows, and southern whitefaces.

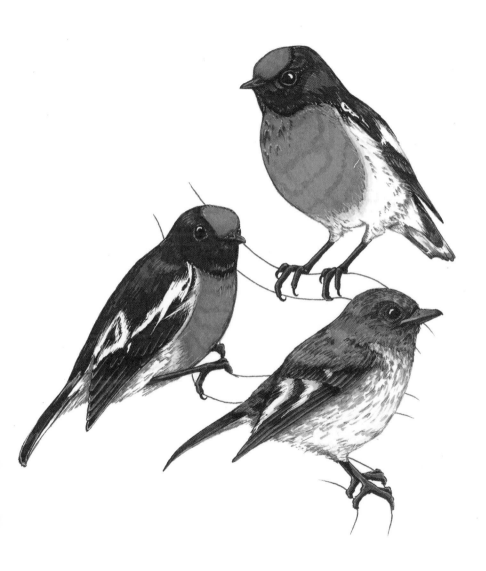

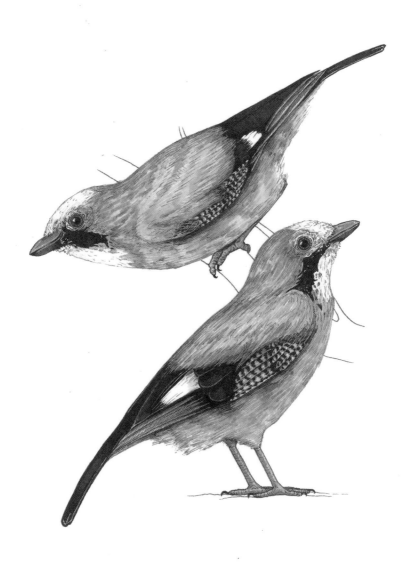

EURASIAN JAY

Garrulus glandarius

DISTRIBUTION
Europe, Asia &
northwestern Africa

SIZE
35cm (14in)
beak-to-tail-tip

DIET
Nuts, seeds, insects, and
small animals, including
carrion

ACTIVITY
Diurnal

MIGRATION PATTERNS
Non-migratory

IUCN STATUS
Least Concern

The Eurasian jay is a shy bird, but uses an impressive array of skills to survive across a variety of harsh wilderness and urban areas. They are wonderful mimics, often imitating fellow bird species, as well as predatory animals (including meowing like cats). These birds are also prolific food hoarders, gathering large numbers of acorns and beechnuts, which they cache away in soil or leaf litter for use during lean times. As a result, the Eurasian jay has played an important role in the proliferation of oak and beech species (such as European and holm oak) across its habitat. Jays may carry seeds over long distances (sometimes traversing several kilometres or miles) where they bury them in the soil – the perfect place for a seed to sprout. A portion of these seeds are forgotten, which then germinate to produce new generations of oak and beech trees. As a result, Eurasian jays have unwittingly provided habitat and food for swathes of fellow species.

RED CROSSBILL

Loxia curvirostra

DISTRIBUTION
North America,
Europe & Asia

SIZE
20cm (8in)
beak-to-tail-tip

DIET
Conifer seeds (including
Aleppo pine, Himalayan
hemlock, black spruce,
Douglas fir and many others)

ACTIVITY
Diurnal

MIGRATION PATTERNS
Not regularly migratory, but may
nomadically move across areas
to seek mature pine cones

IUCN STATUS
Least Concern

The life of the red crossbill is closely intertwined with the health of local conifer forests, which serve as both their habitat and source of food. These birds are a relatively common sight in pine forests across the northern hemisphere, where they gather in large twittering flocks to feed on pine seed. The young birds are a yellow-brown colour, eventually developing bright red plumage as they mature. In a feat of evolutionary genius, one side of their beak crosses over the other, rather like someone might cross their fingers. This surreal-looking beak acts like a crowbar – it allows the crossbill to twist open pine cones and draw out the seeds within using their tongue. As these birds rely entirely on conifer seeds, their movements are dictated by cone production. If their local pine forest fails to fruit one year, they will move on to a new area.

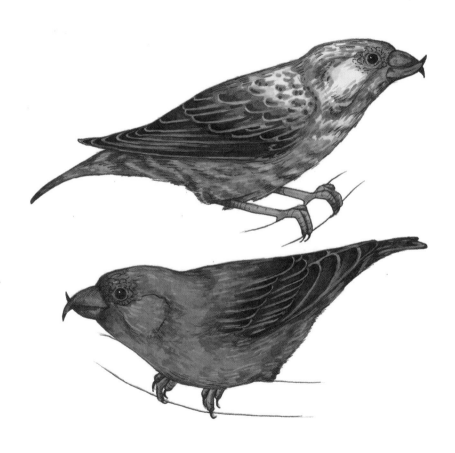

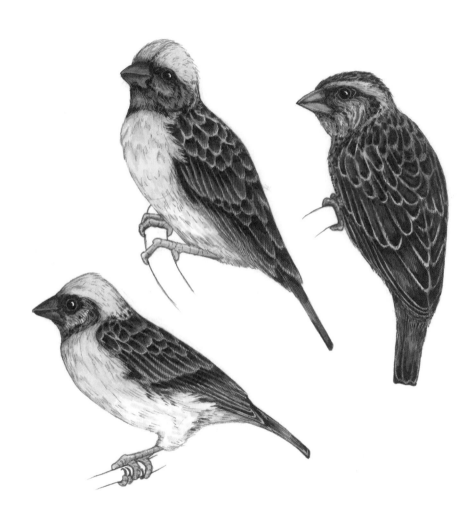

BAYA WEAVER

Ploceus philippinus

DISTRIBUTION
Central &
Southeast Asia

SIZE
15cm (6in)
beak-to-tail-tip

DIET
Small reptiles,
insects and seeds

ACTIVITY
Diurnal

MIGRATION PATTERNS
Non-migratory

IUCN STATUS
Least Concern

The architecturally adept baya weavers are highly social, spending much of their life in a flock feeding at the edges of agricultural or suburban regions. Come breeding season, sociability turns to competition as males expend a huge amount of energy constructing elaborate nests to entice a mate. The baya weaver males choose a clear branch (or the occasional telephone line) where they build their nests. They collect strips of foliage, starting with a simple half hitch knot on a branch. Then they begin the long, arduous process of weaving the fronds over and under one another, building these layers up into a tubular, hanging nest, supplemented with mud to add further structure. Nearby females look on and select a mate based on the quality of his nest.

COMMON TAILORBIRD

Orthotomus sutorius

DISTRIBUTION
Tropical regions of Asia

SIZE
12cm (4.5in)
beak-to-tail-tip

DIET
Insects and other
invertebrates

ACTIVITY
Diurnal

MIGRATION PATTERNS
Non-migratory

IUCN STATUS
Least Concern

The aptly named tailorbirds are known for their shy but diligent efforts at nesting. Using their sharp, needle-like beak, the female tailorbirds carefully puncture holes along the edges of leaves. They then thread these holes with a plant fibre, silk (from insects or spiders), or, in some cases, threads of gathered plastic. These joined leaves form a hammock-like cradle in which the tailorbird can build a nest, ready to hold her eggs in a private roosting suite. Living in the lowland forests and gardens of tropical Asia, common tailorbirds survive mostly on insects and flower nectar, usually remaining out of sight amongst thickets where they can avoid predators.

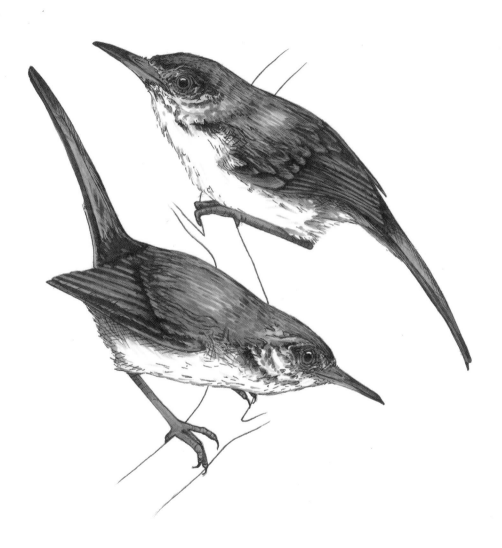

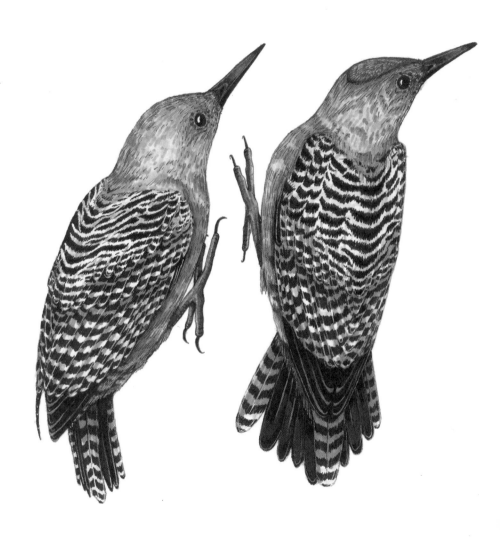

GILA WOODPECKER

Melanerpes uropygialis

DISTRIBUTION
Southwest USA
& Mexico

SIZE
20cm (8in)
beak-to-tail-tip

DIET
Insects, fruit and
small animals, such as
lizards

ACTIVITY
Diurnal

MIGRATION PATTERNS
Non-migratory

IUCN STATUS
Least Concern

The gila (pronounced 'heela') woodpecker lives in the harsh, arid
Sonoran desert that encircles the Gulf of California. Whilst remaining
true to their heritage by using their beaks to drill nesting holes,
instead of choosing hardwood trees (like the Pileated woodpecker,
see pp. 52–3), gila woodpeckers instead prefer to nest in saguaro
cacti. The gila woodpeckers drill a hollow into the soft trunk of the
enormous cacti, and allow it to dry out and harden ahead of the
breeding season. After any hatchlings have fledged, these abandoned
hollows are often used by other desert species, such as cactus wrens
or elf owls. Gila woodpeckers eat a diverse range of foods, but they
have a penchant for the large, red-fleshed fruit of saguaro cacti. As a
result, these birds spread saguaro seeds across the desert, ensuring
food and habitat for future generations of both gila woodpeckers and
other desert-dwelling species.

SOUTHERN CARMINE BEE-EATER

Merops nubicoides

DISTRIBUTION
Sub-equatorial Africa

SIZE
25cm (10in) beak-to-tail (excluding tail-extensions)

DIET
Insects

ACTIVITY
Diurnal

MIGRATION PATTERNS
Spends cooler months in south-central Africa migrating to southernmost Africa for summer

IUCN STATUS
Least Concern

Southern carmine bee-eaters are named for their love of insects – especially bees – which they grab in short, looping flights from an open perch. These birds deftly knock captured bees or wasps against hard surfaces, which usually succeeds in dislodging the stingers and venom, allowing the birds to safely eat them. They are drawn to areas where insect life is disturbed, lingering close to kori bustards, who flush dragonflies, bees and flies out of the undergrowth as they move. They may also be seen circling ahead of wildfires to grab fleeing insects. When breeding season arrives, bee-eaters dig nesting burrows in dry sloping earth or river banks, safe from harsh weather and predators.

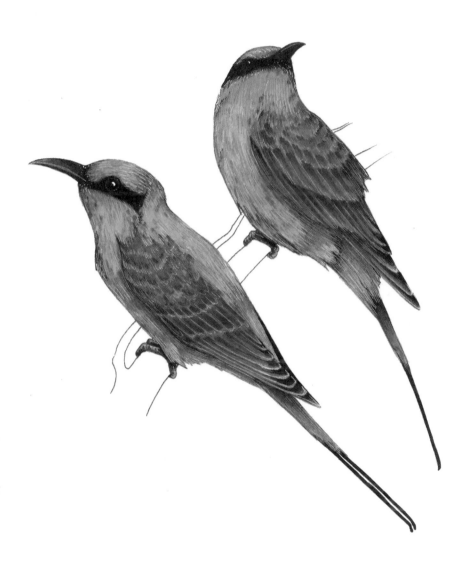

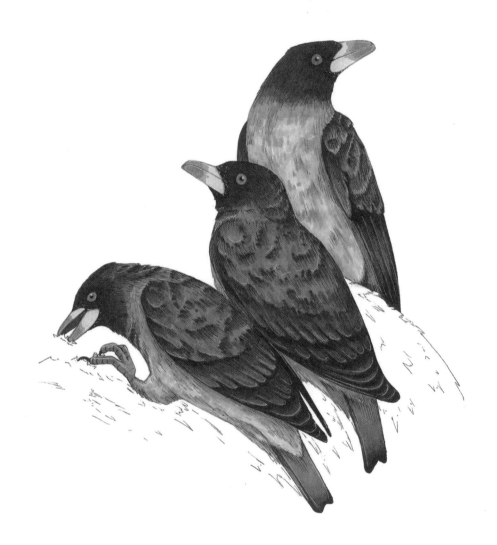

YELLOW-BILLED OXPECKER

Buphagus africanus

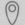

DISTRIBUTION
Africa

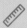

SIZE
20cm (8in)
beak-to-tail-tip

DIET
Insects and other
invertebrates
(primarily ticks)

ACTIVITY
Diurnal

MIGRATION PATTERNS
Non-migratory

IUCN STATUS
Least Concern

The yellow-billed oxpecker is a creature whose existence is closely interlinked with the lives of savannah-dwelling mammals across Africa. These sociable birds spend much of their day on the backs of grazing animals, such as buffalo, cattle, zebras and wildebeest, where they feast on the plentiful supplies of ticks and other ectoparasites which live on the animals. The mammals, in turn, tolerate the rambunctious movements of the oxpeckers – even when there are several birds on their back at once. The oxpeckers will inquisitively hop around, poking about in their host's nostrils, ears and eyes, becoming very familiar with their beasts of burden. They even gather loose hair from their hosts and use it to line the tree hollows they use as nests.

GREATER HONEYGUIDE

Indicator indicator

DISTRIBUTION
Sub-Saharan Africa

SIZE
20cm (8in)
beak-to-tail-tip

DIET
Honeycomb contents
(including beeswax, eggs, grubs
and pupae), and other insects

ACTIVITY
Diurnal

MIGRATION PATTERNS
Non-migratory

IUCN STATUS
Least Concern

Living in the open, dry forests of sub-Saharan Africa, greater honeyguides are renowned for their peculiar relationship with humans. Rather like a pied piper, these birds have a particular rolling call they sing from trees to call attention to themselves. Local people (such as the Yao of Mozambique, or the Hadza peoples of Tanzania, along with many other cultural groups) follow the honeyguides as they dart from tree to tree through the landscape to a nearby beehive. They will then smoke and raid the hive of honey, while the honeyguides feast on the scraps of honeycomb left behind after the harvest. Like cuckoos and cowbirds, greater honeyguides lay their eggs in the nests of other species of birds, leaving them to do the work of raising their chicks.

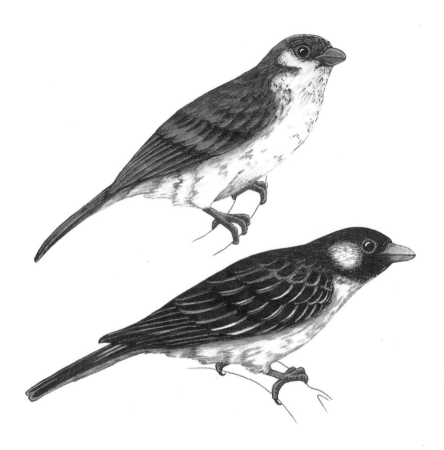

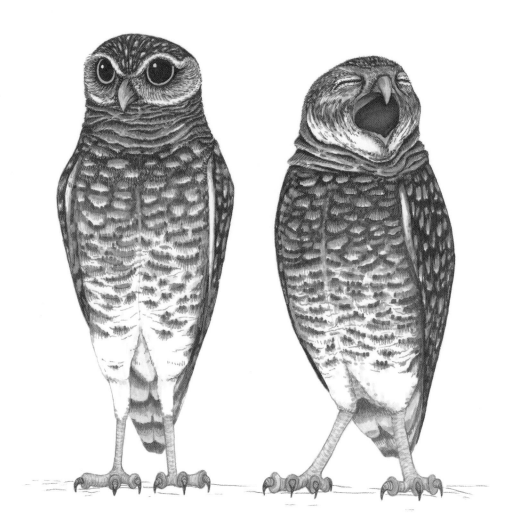

BURROWING OWL

Athene cunicularia

DISTRIBUTION
North & South America

SIZE
22cm (8.8in)
beak-to-tail-tip

DIET
Invertebrates, some small
animals and sometimes
cactus fruit

ACTIVITY
Diurnal

MIGRATION PATTERNS
Largely non-migratory, though
northernmost birds may
migrate to warmer climates
for breeding season

IUCN STATUS
Least Concern

In great contrast to most owls, burrowing owls (also known in some regions as shocos) love sunshine and, rather like a feathery, flying meercat, nest underground in small family groups. These endearingly sleepy-looking owls spend most of their time feeding and rearing young in the open forests and prairies of the Americas, scurrying and hopping about on foot as much as flying. They occupy holes left by ground squirrels and other burrowing animals, which provide a safe spot to spend their nights. By day, they come out to hunt rodents and other small critters to sustain themselves. Cleverly, the burrowing owl is able to create a rattling, hissing noise in imitation of a rattlesnake (a phenomenon known as Batesian mimicry), which readily warns off predators from their family burrows.

BARN OWL

Tyto alba

DISTRIBUTION
Across most of the
world, excluding the
northernmost latitudes

SIZE
Wingspan just under
a metre (nearly 39in)

DIET
Small mammals (particularly
rodents), birds and other
small animals such as lizards
and large insects

ACTIVITY
Nocturnal

MIGRATION PATTERNS
Non-migratory, though
northernmost and southernmost
portions may shift seasonally

IUCN STATUS
Least Concern

Seen in a wide variety of habitats, ranging from tropical forests in
Malaysia to the icy regions of southern Canada, the huge distribution
of the barn owl is a testament to how spectacularly adapted they are
for survival. These ghostly white owls are supreme hunters, feeding
on rodents and other small animals. The leading edge of their wings
have stiff bristly feathers, like an upturned comb – tiny structures that
disrupt air flow and allow the birds to fly silently. The bristles on their
beaks are highly sensitive to vibrations too, and their rounded facial
ruff 'cups' noise, further enhancing their hearing. To top it off, barn
owls have asymmetrically placed ears which help them to better detect
where a sound is coming from. When the breeding season arrives,
barn owls nest in tree hollows.

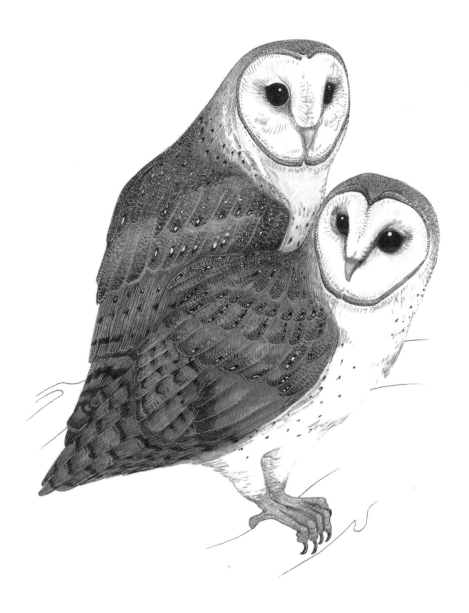

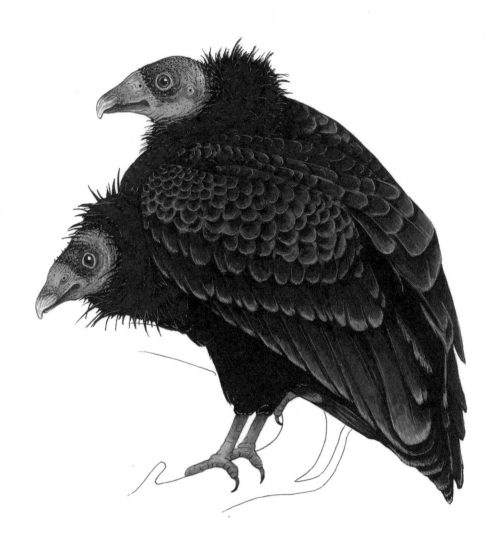

CALIFORNIA CONDOR

Gymnogyps californianus

DISTRIBUTION
Southwestern
North America

SIZE
240–300cm
(95–120in) wingspan

DIET
Carrion

ACTIVITY
Diurnal

MIGRATION PATTERNS
Non-migratory but often
traverse a large territory

IUCN STATUS
Critically
Endangered

The marvellously grim-reaper-esque California condor has made it back from the brink of death. Formally listed as extinct in the wild in the 1980s, these New World vultures have since been nursed back to a slightly healthier population, and now feature sparsely across open dry savanna, scrublands, and conifer forests in California, Arizona, Utah and Mexico. Their enormous wings allow them to glide over huge distances while expending very little energy (*see* Appendix A, pp. 104–5). These bashful birds may look intimidating, but they act as more of a clean-up crew, taking advantage of the nutrients available in carcasses left as roadkill or by predators. Having a featherless head means these birds can remain neat and tidy after snacking on carrion. California condors have the seemingly miraculous ability to have virgin births in captivity. This is a process known as parthogenesis, which is relatively rare in birds, but more common in insects and some animals.

EUROPEAN HONEY BUZZARD

Pernis apivorus

DISTRIBUTION
Europe, Africa &
Western Asia

SIZE
55cm (22in)
beak-to-tail-tip

DIET
Larvae of bees and wasps,
plus some small animals

ACTIVITY
Diurnal

MIGRATION PATTERNS
Breeds in the Palearctic in
summer, and spends winters in
the forests of sub-Saharan Africa
and other southern regions

IUCN STATUS
Least Concern

Like bandits of the woodlands, European honey buzzards live amongst open forests, raiding the nests of wasps and bees for sustenance. When a honey buzzard finds a hive, the bird uses its beak and claws to tear at the comb, from which it can peck at the exposed larvae and pupae. Like the Greater honeyguide (*see* pp. 70–1), these birds tend to feed more on the insects that form the honey – especially during the larval stages – rather than the honey itself. They will even dig at open ground with their claws to get at burrowing wasp nests. As one of the only known predators of the invasive Asian hornet, honey buzzards play a valuable role in ecosystems by suppressing pest insects. The distribution of this species has some overlap with the range of the oriental honey buzzard in the Middle East.

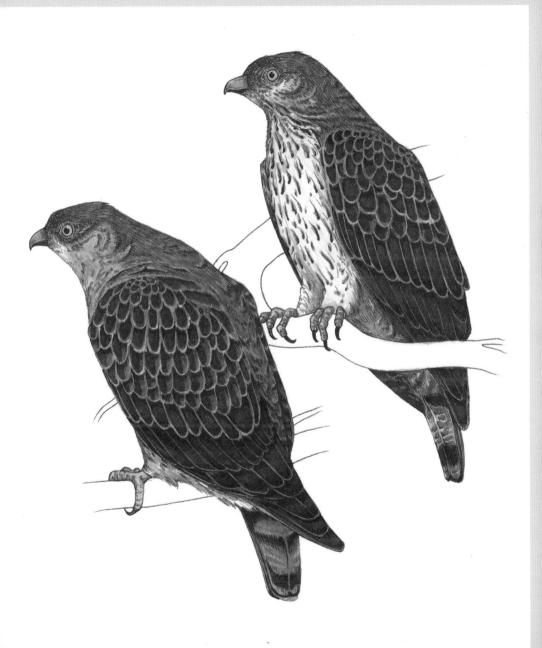

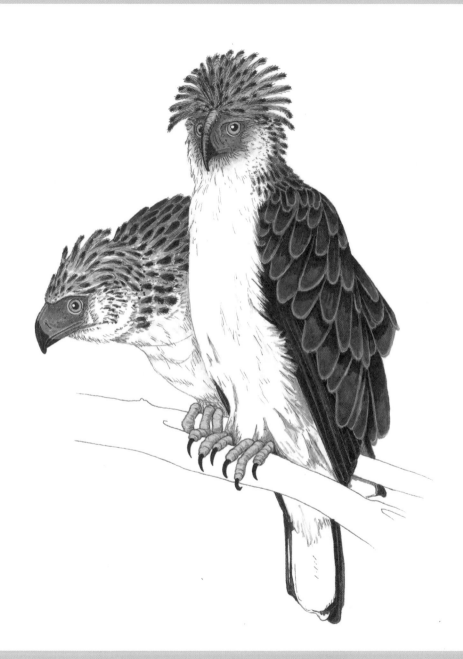

PHILIPPINE EAGLE

Pithecophaga jefferyi

DISTRIBUTION
The Philippines

SIZE
190cm (75in)
wingspan

DIET
Wide array
of animals

ACTIVITY
Diurnal

MIGRATION PATTERNS
Non-migratory but traverse
a large territory

IUCN STATUS
Critically
Endangered

Living in the dense jungle canopy of southeast Asia, the huge Philippine eagle feeds on smaller vertebrate animals (including the occasional monkey), while breeding, nesting, and hunting amongst the treetops. For such a small population, these birds have a major influence over the health of their ecosystem. They are the apex predators within the region, meaning they are the top-down pressure that keeps numbers of bats, flying foxes, rodents, lemurs, birds, and other small animals in check. As these birds require large territorial tracts of forest in which to hunt, they influence species dynamics over large areas of land. The parents raise a young eagle for more than a year after hatching, and, like the Wandering albatross (*see* pp. 96–7) and the California condor (*see* pp. 76–7), they only breed in alternate years.

PEREGRINE FALCON

Falco peregrinus

DISTRIBUTION

Across most of the world, excluding Antarctica, Aotearoa New Zealand and the far northern Arctic regions

SIZE

100cm (40in) wingspan

DIET

Birds and other small animals

ACTIVITY

Diurnal, often hunting around twilight hours, but may hunt into the night in urban areas due to light pollution

MIGRATION PATTERNS

Some portions of the population will move to cooler regions for breeding in spring and summer, and return to warmer climates for winter

IUCN STATUS

Least Concern

Seen both in the steep rocky watercourses of the Grand Canyon and in the narrow skyscraper blocks of cities around the world, peregrine falcons can reach insane dive speeds, faster than 320km per hour (200mph). In horizontal flight they can easily fly as fast as 150km per hour (93mph). These birds are expert hunters and, primarily feeding on other birds, they exert a strong influence on local bird populations. Since they suppress their preferred prey species, this leads to increases in the populations of non-preferred prey species. Peregrine falcons generally nest amongst high cliffs, though they have now readily assumed roosts amongst skyscrapers in urban centres, where feral pigeons make for easy dinners.

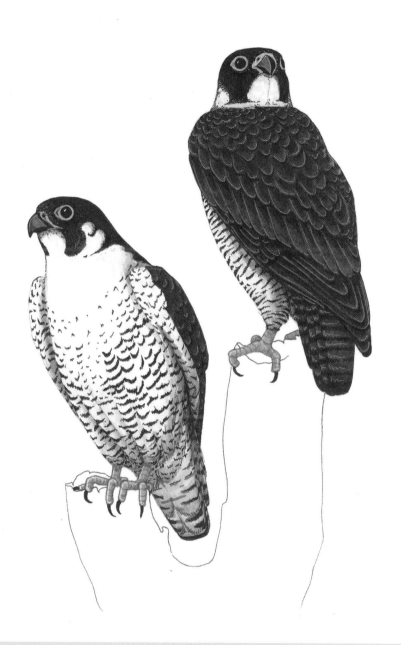

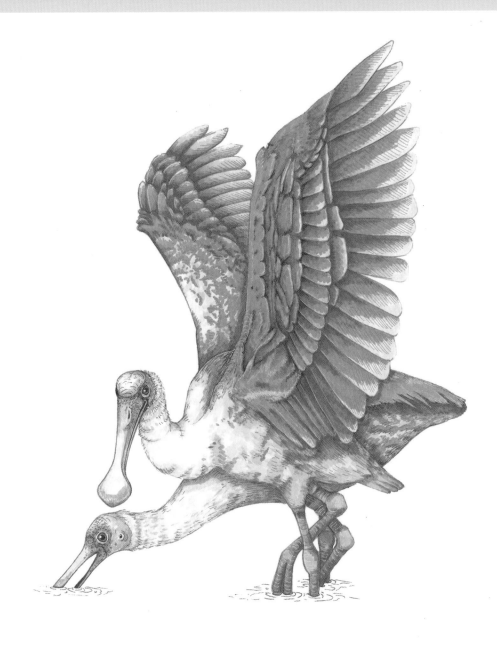

ROSEATE SPOONBILL

Platalea ajaja

DISTRIBUTION
North & South
America

SIZE
75cm (30in)
beak-to-tail-tip

DIET
Crustaceans, water-
borne invertebrates, small
amphibians and small fish

ACTIVITY
Diurnal

MIGRATION PATTERNS
Some portions of the population
migrate to more equatorial
regions over winter, and
disperse again during summer

IUCN STATUS
Least Concern

Like delicate tulle-wearing dancers, picking their way between mangrove forests in the Americas, roseate spoonbills seem a little at odds with their swampy surrounds. These rose-coloured birds feed in mixed flocks amongst American white ibises and egrets, and nest in trees lining waterways. Like flamingos, their pink colour comes from their crustacean-rich diet, whose carotenoids migrate into the spoonbill's plumage, turning their feathers a lush salmon colour. Between bouts of preening, they rhythmically sweep their sensitive bill from side to side to find food in shallow waters, relying on the sensory signals from their submerged bill to hunt crustaceans, frogs and invertebrates. Because these birds rely on a dense concentration of aquatic life to sustain themselves, their presence serves as an indicator of environmental health.

BLACK HERON

Egretta ardesiaca

DISTRIBUTION
Sub-Saharan Africa

SIZE
50cm (19.5in) tall

DIET
Fish, amphibians, and
aquatic invertebrates

ACTIVITY
Diurnal, but will also
hunt around twilight

MIGRATION PATTERNS
Non-migratory but some
portions of the population
may move nomadically
between water bodies

IUCN STATUS
Least Concern

These wraith-like, grey-cloaked birds stalk through African swamplands, marshes, and other shallow waters, on the prowl for fish, frogs, and other small vertebrates. These hunters don't merely stalk the shallows as many other herons do. Instead, they pause, gracefully unfurl their wings (like some ominous, water-borne Nosferatu), and draw them into an umbrella shape, tucked close above their lowered head. This prevents any light from hitting the water directly below the heron. There is some debate over whether this attracts fish by deceiving them into thinking they are safely resting in the lee of a river bank, or better allows the heron to see through the reflective water and spot prey. Either way, the fish linger within reach of the stone-still heron who chooses the perfect moment to strike. This method of hunting is known as 'canopy feeding'.

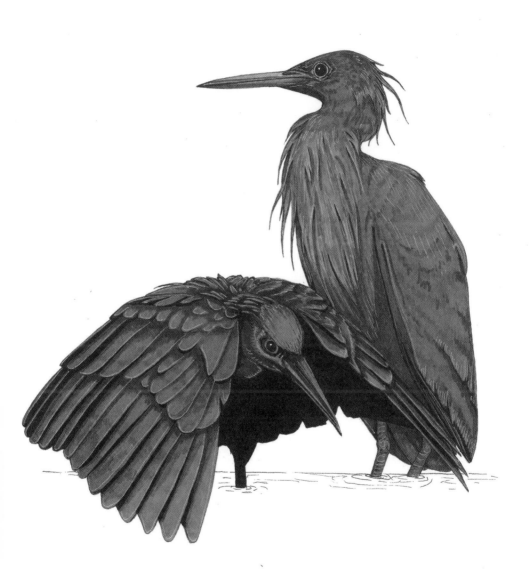

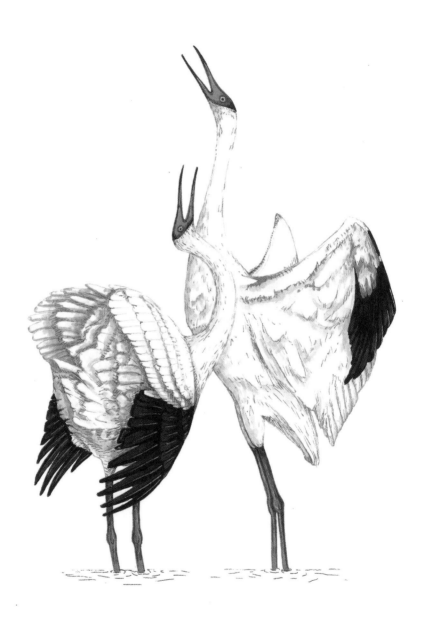

SIBERIAN CRANE

Leucogeranus leucogeranus

DISTRIBUTION
Asia & far Eastern
Europe

SIZE
140 cm (55in)
beak-to-tail-tip (standing
around 1.3m tall)

DIET
Plant matter and
small animals such as
fish and insects

ACTIVITY
Diurnal

MIGRATION PATTERNS
Summers are spent in the Arctic
tundra, migrating to the Yangtze river
basin in China to breed during winter,
while a remnant population travels
between Russia and India

IUCN STATUS
Critically
Endangered

When elegant Siberian cranes reach their breeding grounds in the
Yangtze river basin, they seek out and dance with their mates, hopping,
bowing, and tilting their heads back to call. They delicately pick through
shallow waters on long legs, grazing for food, tugging up rhizomes
of aquatic vegetation or hunting small critters on the silty bottom.
Though only a tiny portion of the western Siberian crane population
remains, these unflagging creatures annually travel 6000 km, flying
over the Himalayas (the highest mountain range in the world) to reach
their southern breeding grounds in Iran and northern India each
winter. The modification of land, particularly the draining of wetlands
for agriculture, means these birds now breed almost exclusively in
Poyang Lake, China, then retreat to the Arctic tundra over summer.

MAGNIFICENT FRIGATEBIRD

Fregata magnificens

DISTRIBUTION
Central & South
American coastlines

SIZE
220cm (87in)
wingspan

DIET
Fish and other
sea creatures

ACTIVITY
Diurnal

MIGRATION PATTERNS
Non-migratory

IUCN STATUS
Least Concern

Named after fast-sailing warships, magnificent frigatebirds are truly airborne oceanic warlords, soaring above Central American islands and coastlines. They have an enormous wingspan – over two metres, the largest of any frigatebird (*see* Appendix A, pp. 104–5) – and are therefore able to fly great distances with limited energy expenditure, soaring over waters where they primarily hunt fish. However, these birds are also effective at thieving food from other ocean-fishing species. They do so by harassing these other birds until they drop their catch, allowing the speedier frigatebirds to retrieve the food before it hits the ocean's surface. Their intimidating size and flying prowess is made all the more striking by the large, inflatable gullet the male frigate birds possess (known as a gular sac), used to attract females. After mating, these enormous birds nest amongst mangroves and other plants on coastal islands.

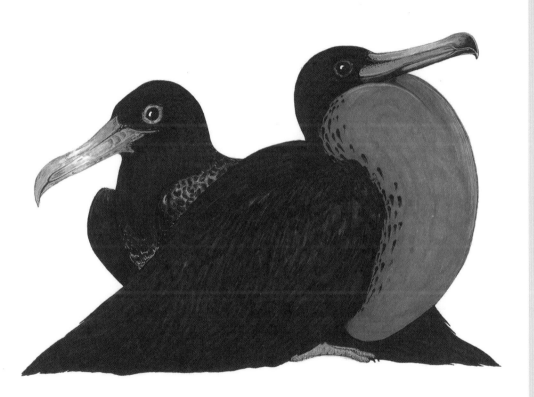

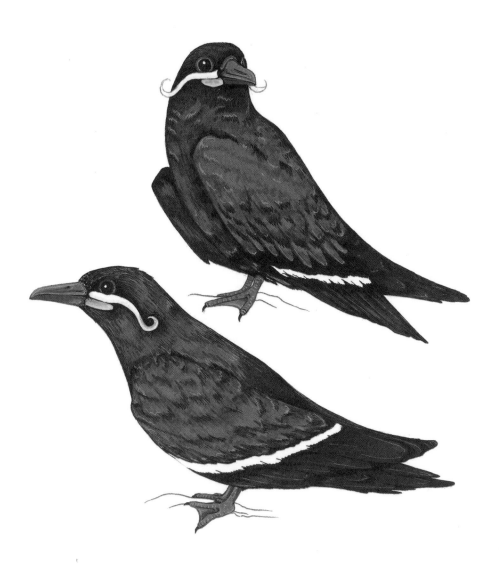

INCA TERN

Larosterna inca

DISTRIBUTION
Western coast of
South America

SIZE
40cm (16in)
beak-to-tail-tip

DIET
Fish and other water-
dwelling organisms

ACTIVITY
Diurnal

MIGRATION PATTERNS
Non-migratory but will
move locally to seek food

IUCN STATUS
Near
Threatened

Inca terns, whose distribution mirrors that of the ancient Incan Empire, have a life inexorably linked with the ocean. The Humboldt current, which flows northward along the western coast of South America, carries cold water to meet more tropical waters near Peru, causing an upwelling of nutrients to the surface. As a result ocean life – and bird life – flourishes there. Inca terns feed on both zooplankton and fish (primarily anchovy) by cruising above ocean waters, then swooping down to grab fish from just below the surface. These mustachioed birds will even steal food directly from the mouths of sea lions who hunt in the waters below them. Their ornate facial plumage is most brilliant on the healthiest birds, and likely plays a role in mate selection amongst their large, cliff-housed colonies.

LONG-TAILED DUCK

Clangula hyemalis

DISTRIBUTION

Northern regions
of the northern
hemisphere

SIZE

50cm (19.5in) beak-
to-tail-tip (excluding long
tail tip on males)

DIET

Molluscs, crustaceans
and fish

ACTIVITY

Diurnal

MIGRATION PATTERNS

Breeds in summer in northern
Arctic regions, and retreats to
spend winter in more southern
areas, such as the Great Lakes
region of North America, or
the Baltic Sea in Europe

IUCN STATUS

Vulnerable

Paddling through the marshlands, tundra lakes, and open seas of the
icy Arctic circle, ornate long-tailed ducks live in large flocks, spending
most of their days on or in the water. They feed on an array of aquatic
life, including plankton, small fish, caddisflies, mussels (e.g. Baltic blue
mussels), crabs, and other crustaceans. Only males have the long tail,
which is about 12cm (5in) long. These birds spend much of their day
diving underwater in search of food, and can dive to huge depths – up
to 55 metres (180 feet) – by using their wings to assist their dive, almost
'flying' underwater. These birds produce bioavailable nutrients that
feed back into their oceanic and freshwater habitats.

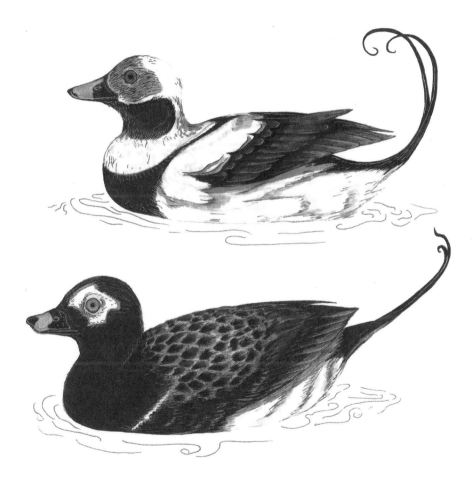

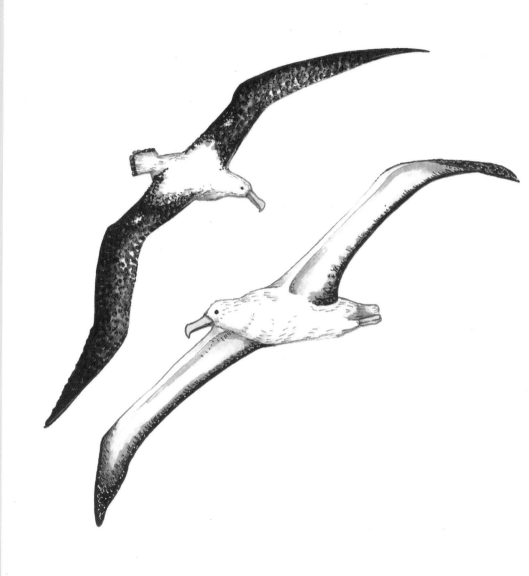

WANDERING ALBATROSS

Diomedea exulans

DISTRIBUTION
Southern ocean
(encircling Antarctica)

SIZE
300cm (118in)
wingspan

DIET
Marine creatures
(e.g. fish, cephalopods,
crustaceans)

ACTIVITY
Diurnal though
may remain on the
wing overnight

MIGRATION PATTERNS
Traverses large territory across
Southern Ocean, returning to
the same breeding grounds
every two years

IUCN STATUS
Vulnerable

These ponderous, graceful birds are some of the largest in the world, with a similar wingspan to the California condor (*see* pp. 76–7 and Appendix A, pp. 104–5). They spend much of their lives flying over and exploring the Southern Ocean (also known as the Antarctic Ocean), which encircles the South Pole. Wandering albatross habitually forage a long way out into the open ocean in pursuit of the fish and squid they feed on. They can remain on the wing for immense periods of time without landing; as a result, they occasionally circumnavigate the southern ocean multiple times in a single year. This means some wandering albatross fly 120,000 km (25,000–75,000 miles) in a season, all while foraging and taking short breaks to rest on the ocean's surface. They nest on land in the warmer months and, due to the intensive parental effort to raise and protect their chicks, only breed every second year.

ADÉLIE PENGUIN

Pygoscelis adeliae

DISTRIBUTION
Antarctica

SIZE
70cm (27.5in)
tall

DIET
Fish

ACTIVITY
Diurnal

MIGRATION PATTERNS
Migrates inland for the
summer breeding season,
spends winter at the edge of
fast (attached) ice

IUCN STATUS
Least
Concern

The feistiest of all penguins, Adélies stand around half the height of emperor penguins, but what they lack in stature they make up for with fiery personality. Waddling with speed and purpose through flocks along Antarctica's shores, these birds have no trouble demanding space or respect with flipper-slaps, beak-nips and hot-tailed pursuits. In between tousles with fellow birds, they spend much of their time swimming in icy ocean waters, feeding on krill, Antarctic silverfish, and jellyfish. Adélie penguins rely on the upwelling currents below Antarctica, which ensure the phytoplankton food chain blossoms. In spring, these tough little birds waddle (and belly slide) inland to breed. They build a rounded nest of pebbles, which they 'plug' with their belly to incubate the eggs within. The bare inland rocks absorb the warmth of the sun, helping to keep the eggs warm.

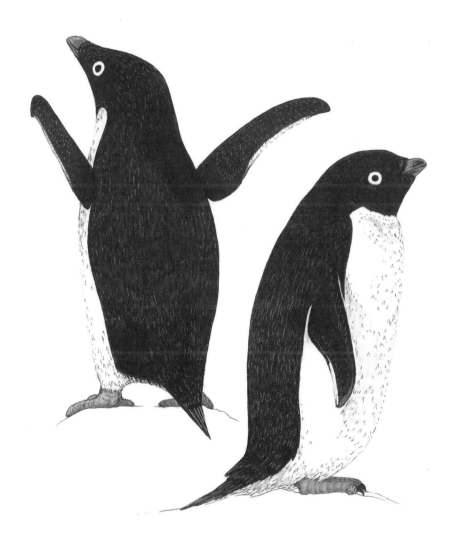

APPENDICES

The following appendices are intended to provide you with some different perspectives on the bird species you've encountered in this book. The first appendix shows species at approximately relative scale, allowing you to compare species side-by-side. The second appendix shows some basic bird anatomy and features, illustrating how beaks, feet, and feathers relate to diet and habitat. The third and fourth appendices show each featured species in flight.

APPENDIX A: RELATIVE SIZE OF BIRDS

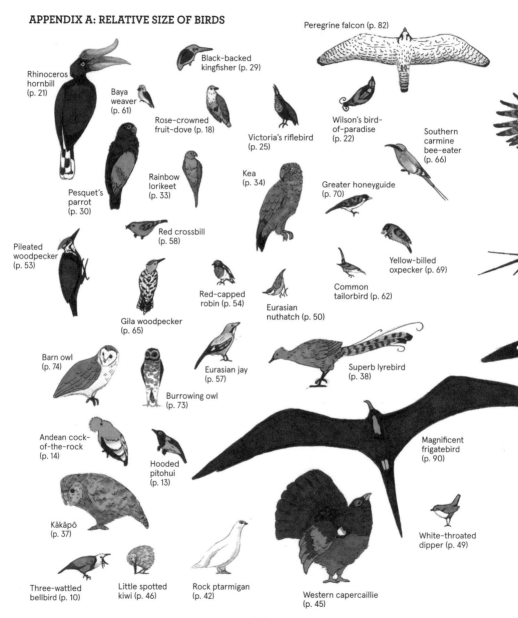

Rhinoceros hornbill (p. 21)

Baya weaver (p. 61)

Black-backed kingfisher (p. 29)

Peregrine falcon (p. 82)

Rose-crowned fruit-dove (p. 18)

Victoria's riflebird (p. 25)

Wilson's bird-of-paradise (p. 22)

Southern carmine bee-eater (p. 66)

Pesquet's parrot (p. 30)

Rainbow lorikeet (p. 33)

Kea (p. 34)

Greater honeyguide (p. 70)

Pileated woodpecker (p. 53)

Red crossbill (p. 58)

Yellow-billed oxpecker (p. 69)

Red-capped robin (p. 54)

Common tailorbird (p. 62)

Gila woodpecker (p. 65)

Eurasian nuthatch (p. 50)

Barn owl (p. 74)

Eurasian jay (p. 57)

Superb lyrebird (p. 38)

Burrowing owl (p. 73)

Andean cock-of-the-rock (p. 14)

Hooded pitohui (p. 13)

Magnificent frigatebird (p. 90)

Kākāpō (p. 37)

White-throated dipper (p. 49)

Three-wattled bellbird (p. 10)

Little spotted kiwi (p. 46)

Rock ptarmigan (p. 42)

Western capercaillie (p. 45)

Philippine eagle
(p. 81)

California
condor (p. 77)

European
honey
buzzard
(p. 78)

Hoatzin
(p. 26)

Zunzuncito
(p. 2)

Inca tern
(p. 93)

Wandering
albatross (p. 97)

'I'iwi (p. 1)

Saffron
toucanet
(p. 9)

Satin
bowerbird
(p. 17)

Blue manakin
(p. 6)

Mrs Gould's sunbird
(p. 5)

Long-tailed duck
(p. 94)

Adélie penguin
(p. 98)

Black heron
(p. 86)

Roseate spoonbill
(p. 85)

Siberian crane
(p. 89)

Southern cassowary
(p. 41)

Approximately 160cm (63in)

APPENDIX B: DIVERSE BIRD ANATOMY

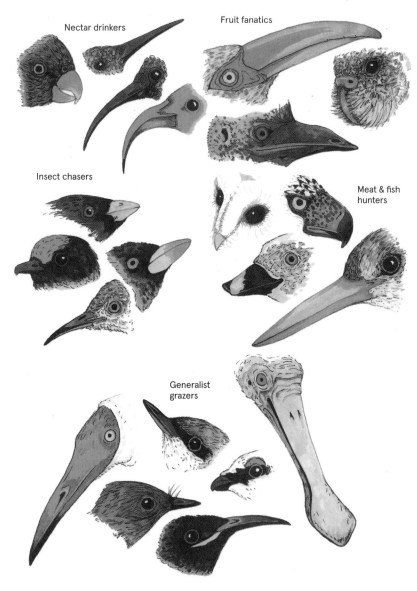

Nectar drinkers

Fruit fanatics

Insect chasers

Meat & fish hunters

Generalist grazers

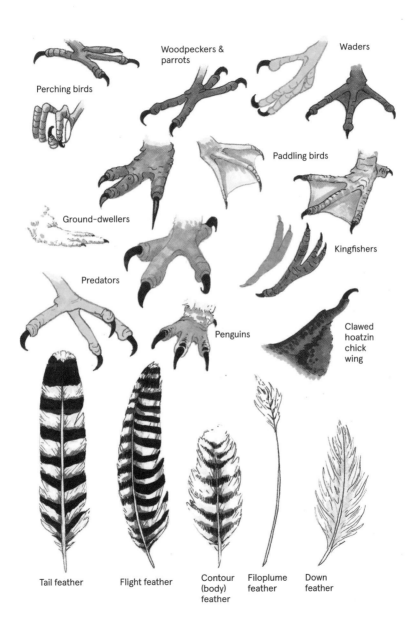

Woodpeckers & parrots

Waders

Perching birds

Paddling birds

Ground-dwellers

Kingfishers

Predators

Penguins

Clawed hoatzin chick wing

Tail feather

Flight feather

Contour (body) feather

Filoplume feather

Down feather

APPENDIX C: BIRDS IN FLIGHT 1

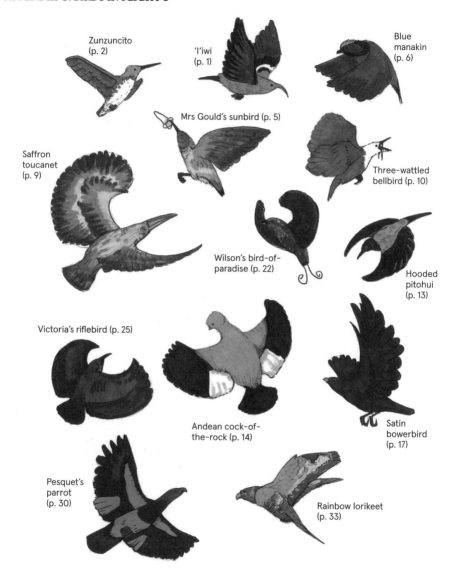

Zunzuncito (p. 2)

'I'iwi (p. 1)

Blue manakin (p. 6)

Mrs Gould's sunbird (p. 5)

Saffron toucanet (p. 9)

Three-wattled bellbird (p. 10)

Wilson's bird-of-paradise (p. 22)

Hooded pitohui (p. 13)

Victoria's riflebird (p. 25)

Andean cock-of-the-rock (p. 14)

Satin bowerbird (p. 17)

Pesquet's parrot (p. 30)

Rainbow lorikeet (p. 33)

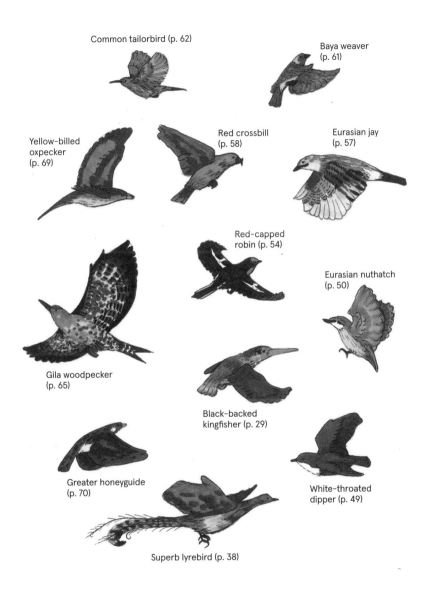

Common tailorbird (p. 62)

Baya weaver (p. 61)

Yellow-billed oxpecker (p. 69)

Red crossbill (p. 58)

Eurasian jay (p. 57)

Red-capped robin (p. 54)

Eurasian nuthatch (p. 50)

Gila woodpecker (p. 65)

Black-backed kingfisher (p. 29)

Greater honeyguide (p. 70)

White-throated dipper (p. 49)

Superb lyrebird (p. 38)

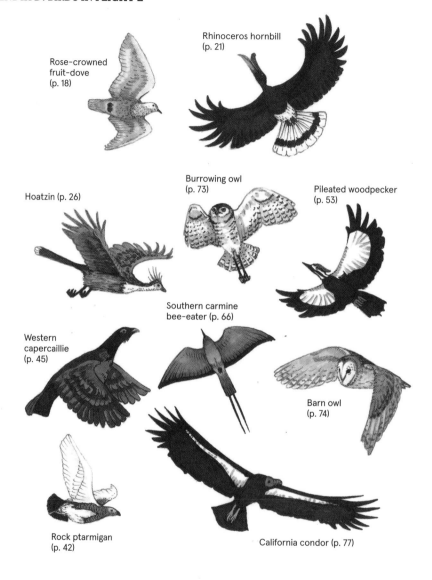

Rose-crowned
fruit-dove
(p. 18)

Rhinoceros hornbill
(p. 21)

Hoatzin (p. 26)

Burrowing owl
(p. 73)

Pileated woodpecker
(p. 53)

Western
capercaillie
(p. 45)

Southern carmine
bee-eater (p. 66)

Barn owl
(p. 74)

Rock ptarmigan
(p. 42)

California condor (p. 77)

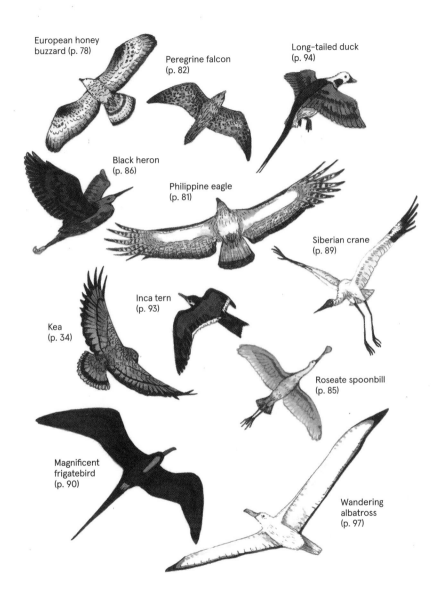

European honey buzzard (p. 78)

Peregrine falcon (p. 82)

Long-tailed duck (p. 94)

Black heron (p. 86)

Philippine eagle (p. 81)

Siberian crane (p. 89)

Inca tern (p. 93)

Kea (p. 34)

Roseate spoonbill (p. 85)

Magnificent frigatebird (p. 90)

Wandering albatross (p. 97)

111

RESOURCES FOR BIRDWATCHERS

BOOKS

Local field guides: Often regional guides for a specific area (e.g. Todd Telander's *Birds of the Pacific Northwest*) can be found at national park offices or local information offices. These will provide specific directions of where and when is best to see certain species in that area.

National (or continental) field guides: A good long-term investment is a field guide that covers your whole country or continent. Some examples include:
- *The Field Guide to the Birds of Australia* by Graham Pizzey & Frank Knight
- *Birds of Europe* by Lars Svensson, Dan Zetterström & Killian Mullarney
- *Sibley's Guide to Birds* by David Allen Sibley (a North American guide)

Some other books to spark your passion for birds and birdwatching:
The Big Twitch, by Sean Dooley, is a biographic birdwatching adventure based in Australia. *Where Song Began*, by Tim Low, explores the fascinating ecological influences that shaped modern birds. *The Call of the Reed Warbler*, by Charles Massy, illustrates the power of landscape management in sustaining biodiversity. *Feral* by George Monbiot and *The Wild Places* by Robert Macfarlane suggest some new ways of looking at 'wild' spaces and the animals that occupy them.

ONLINE RESOURCES

An application form of a field guide (e.g. Morcombe's *Birds of Australia*) allows you to access all of the information in a birdwatching guide via your phone, making it easy to travel with. The free *Merlin Bird ID* app by Cornell Lab, for example, uses citizen-contributed data to help birdwatchers ID species across the globe.

I would also encourage birdwatchers to use the eBird app, or website (ebird.org/home) which allows users to create their own sighting lists. The IUCN Red List of Threatened Species (www.iucnredlist.org/en) provides an understanding of current population statuses of species across the globe, and can help you appreciate the significance of local species when you see them.

COMMUNITY

As a budding birdwatcher, going out with experienced birdwatchers helped me immensely. I encourage you to find a local group of other people interested in birdwatching and share the journey with them. Try seeking out a birdwatching tour at your nearest nature reserve or national park, or search for birdwatching social media communities local to you. Some of the best learning comes from experienced birdwatchers who are willing to share their wisdom and tricks of the trade with you.

ACKNOWLEDGEMENTS

Thanks to Melissa Kayser for another wonderful opportunity to nerd out over birds, Amanda Louey for your help bringing the book together, Kate Kiely for your edits and wonderful philosophical chats, and George Saad for a beautiful book design. Thanks also to Collin Vogt for your proofreading efforts and Patrick Cannon for typesetting. My gratitude to the team at the IUCN for sharing important conservation information, and to eBird for continuing to offer such vital resources to the public. Many thanks to Jason Caruso, Jason Fehon (@beyond.the.nest), Sofia Strang (@strange_sofia) and Jennifer Mancuso (@birdladyaz) for generously sharing species reference photos with me. Thanks to Stephen, Leecia, Kate, Orien, Claryssa, Sean and Vera for their constant support. Finally an enormous thank-you to birdwatching communities across the globe, big and small, for supporting birds and the ecosystems that sustain them.

ABOUT THE AUTHOR

Georgia Angus is an author and artist who lives on the lands of the Kulin Nation in south-east Australia. She has published two other books, *100 Australian Birds* and *100 Australian Butterflies, Bees, Beetles & Bugs*.

Published in 2023 by Hardie Grant Explore, an imprint of Hardie Grant Publishing

Hardie Grant Explore (Melbourne)
Wurundjeri Country
Building 1, 658 Church Street
Richmond, Victoria 3121

Hardie Grant Explore (Sydney)
Gadigal Country
Level 7, 45 Jones Street
Ultimo, NSW 2007

www.hardiegrant.com/au/explore

Distribution maps were compiled using data from eBird (https://www.ebird.org), accessed in February, 2023. Distribution patterns of species will shift over time.

Conservation status information was supplied by The International Union for Conservation of Nature (IUCN) Red List of Threatened Species™. IUCN. 2022. *The IUCN Red List of Threatened Species. Version 2022-2*. <https://www.iucnredlist.org. Accessed [12-01-23].>

A catalogue record for this book is available from the National Library of Australia

Hardie Grant acknowledges the Traditional Owners of the Country on which we work, the Wurundjeri People of the Kulin Nation and the Gadigal People of the Eora Nation, and recognises their continuing connection to the land, waters and culture. We pay our respects to their Elders past and present.

Birds with Personality
ISBN 9781741178289

10 9 8 7 6 5 4 3 2 1

Publisher: Melissa Kayser
Project editor: Amanda Louey
Editor: Kate Kiely
Proofreader: Collin Vogt
Design: George Saad
Typesetting: Patrick Cannon
Production coordinator: Simone Wall

Colour reproduction by Patrick Cannon and Splitting Image Colour Studio
Printed and bound in China by LEO Paper Products LTD.